100 Creative
Drawing Ideas

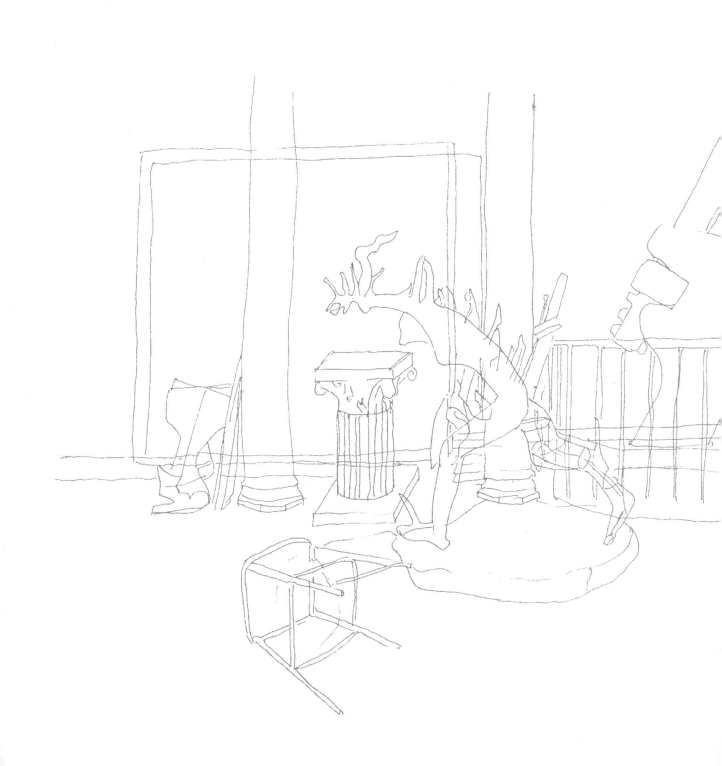

100 Creative Drawing Ideas

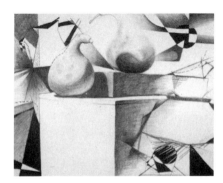

Compiled and edited by

ANNA HELD AUDETTE

SHAMBHALA Boston & London 2004

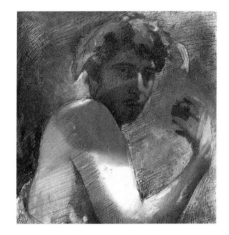

Shambhala Publications, Inc.
Horticultural Hall
300 Massachusetts Avenue
Boston, Massachusetts 02115
www.shambhala.com

13 12 11 10 9 8 7 6 5 4

Printed in the United States of America

♾ This edition is printed on acid-free paper that meets the
American National Standards Institute Z39.48 Standard.
Distributed in the United States by Random House, Inc.,
and in Canada by Random House of Canada Ltd

Library of Congress Cataloging-in-Publication Data
100 creative drawing ideas / compiled and edited by
Anna Held Audette.— 1st
American pbk. ed.
p. cm.
ISBN-13 978-1-59030-105-0 (pbk.: alk. paper)
ISBN-10 1-59030-105-6
1. Drawing—Technique. I. Title: One hundred creative
drawing ideas. II. Audette, Anna Held.
NC730 .A15 2004
741.2—dc21
2003013542

To

LGA

with lasting gratitude

———————

Contents

Introduction

THE UNDERLYING concept for this book came from my observation as an art student, and later as a university professor, that students are often given dull and hackneyed drawing problems. Such assignments do not bring out the best in student work, nor do they make for much pleasure and creativity in their imagery. In my many years as a teacher, I developed some assignments that my students seemed to enjoy and to which they brought an increased measure of constructive thinking. Later it occurred to me that other teachers must also have invented challenging problems, but those discoveries rarely went beyond their classrooms.

This book is a compilation of drawing assignments obtained from effective teachers across the country and a few from abroad. They vary greatly in concept and philosophy. The accompanying images illustrate ways in which their students have addressed the assignments and are included to help the reader visualize what might result from the written description. The students' drawings are not intended to be definitive interpretations, and sometimes they may even appear to suggest a narrower vision than that of the text. I should also say that the ideas behind certain assignments are "in the air," and it is quite possible that two people may come up with a similar idea independently. To the best of my knowledge, all the contributors were convinced of the originality of their work.

These assignments have been assembled for use by teachers at all levels and for anyone undertaking independent study. The instructors who have contributed their ideas to this book range over six decades in experience and have very different teaching philosophies, but all of them have found the assignments they contributed to be very effective in their classrooms. They originally created these ideas for classes ranging from college freshmen to graduate students, but I leave it up to the readers

to decide for which level they would like to use a given problem. Like songs, these assignments may be interpreted for use by the beginner or scored for an accomplished musician.

Because teaching is such an individual commitment, no instructional theory is proposed. Each assignment may be plugged into a syllabus wherever an instructor feels it would contribute to the course. In addition, like recipes in a cookbook, the problems may be used in their present form, or instructors may adapt them to their own ways of thinking, or even take them as jumping-off points for the creation of new assignments. With a few exceptions, where the problem's definition has specific requirements, the assignments do not carry suggestions for materials or time allotments. This is because teachers have strong opinions about what techniques are appropriate and how much time is adequate for certain tasks, so in this respect too, I leave those choices up to the reader. Occasionally, where I felt it might be helpful, there are notes that explain a bit more about how the contributing instructor handles the assignment or what background material may be useful.

The enjoyment of teaching is closely related to the energy and excitement generated in a classroom. The ideas in this book should provide fresh material for any drawing curriculum. For that matter, some of the assignments would work equally well in a painting or printmaking class.

I am extremely grateful for the generosity of the one hundred people who shared their teaching ideas with me and took the time amid their academic obligations to work through the drafts of their assignments and provide student drawings and releases for their publication.

ANNA HELD AUDETTE

1 | *Ice Breakers*

*F*OR MANY INSTRUCTORS the first day of the semester is problematic. Students arrive with an unknown amount of drawing experience and no materials to work with. Typically teachers say a few words about what their class will cover, distribute a syllabus, and give a list of needed supplies. Then the class is dismissed early. It is an unfulfilling experience for all involved. The exercises in this section have been developed to make the first day interesting and creative. They do not presume a specific level of drawing experience and thus are easily undertaken by anyone. At the same time they do give the instructor some idea of the drawing competence of the class and may be helpful in planning how to present subsequent assignments.

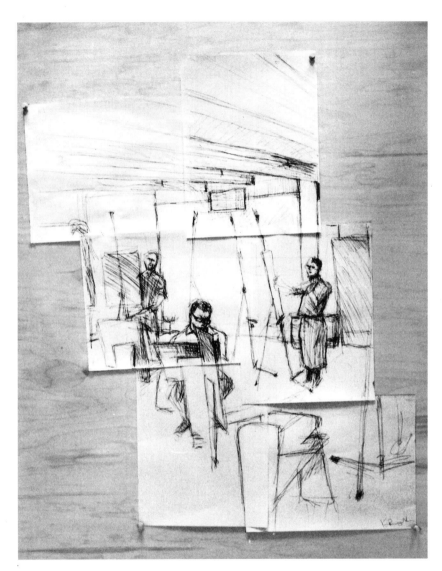

Ken Ragsdale.
Ballpoint pen.

The First Day

JoAnne Carson | *University at Albany, State University of New York*

A *project for the first day of class.*

Every instructor faces the problem of what to do on the first day of class. JoAnne Carson says that students typically arrive without drawing materials, expecting only to pick up the course syllabus and a materials list. She designed this project specifically so that the first class meeting would include a drawing session.

Each student receives six sheets of 8½" × 11" paper and a pen.[1] They are then instructed as follows:

> You may draw anything in the room, and your composition must fill the entire paper. After a short period (say 10–15 minutes), tape a second piece of paper adjacent to and slightly overlapping any edge (including a diagonal) of your existing drawing. Continue your drawing on the second sheet, thus enlarging the composition to include a view that is congruent to the first drawing's composition.
>
> After another equal work period, tape a third sheet to any edge of the first two, and position it in such a way that it significantly alters the composition. Your drawing now describes a much more extensive area than was visible on the first sheet. In this larger field you begin to include the floor, ceiling, and perhaps views into a hallway or out of the window. The project continues in similar fashion until all six sheets are used.

This project of building a drawing automatically creates compositions that are spatially much more dynamic than those usually produced by beginning students.

Keen Observation

Monique Fouquet | *Emily Carr Institute of Art and Design, Vancouver, B.C.*

Focusing entirely on what you see at the moment.

Because Monique Fouquet believes that keen observation is essential to developing hand-eye coordination, she has her students work from an object that is free from all visual forms of association. This assignment is an intense process during which students, because they are free from trying to make their drawing look like something they have seen before (such as a still life, figure, or landscape), focus entirely on what they see at the moment.

> You are given a small amount of clay and asked to form a ball. From a range of drawing tools and materials,[2] select a medium you feel will best convey the material and texture of the clay ball. You have 5 minutes only to draw the subject.
>
> Now look at each drawing and imagine that you have just entered the room and are trying to guess what the drawn ball is made of. How convincing is each representation, and how has this been achieved?
>
> Continue on with more 5-minute drawings of the ball, avoiding references to anything other than the texture, weight, and feel of the clay.
>
> Conclude by squeezing the clay in one hand. On a large piece of paper (approximately 4' × 5'), on the wall, locate the new shape that looks like the negative space of a tight fist.[3] Work from the clay model for about an hour, trying to render the volume and tonal values of the clay form.
>
> The clay is then put aside as you continue to develop your drawing using at least three more different drawing materials.

In the end, the drawing is no longer a portrait of the clay form but rather an account of the process of looking at an object intensely and of experimenting with new and familiar materials.

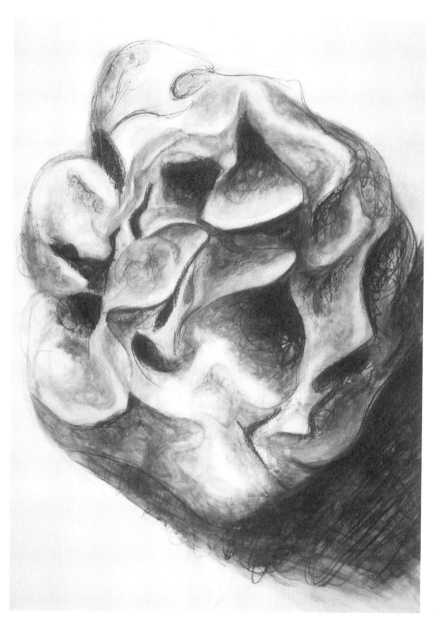

Diana Lopez Soto.

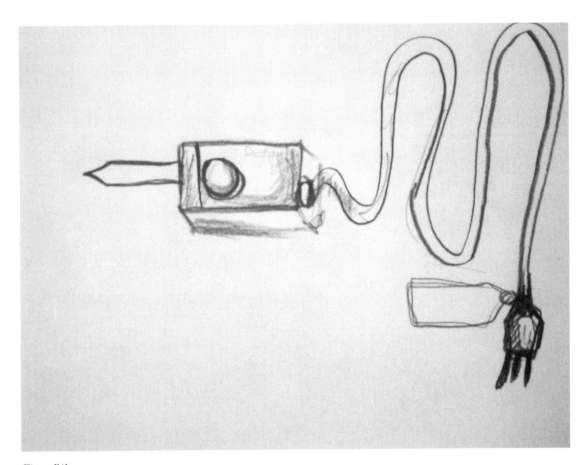

Fiona Riley.

Draw Only What You Are Told

Barry Gazzard | *University of Western Sydney, NSW, Australia*

Drawing an object without seeing it or knowing what it is.

Barry Gazzard says he has one favorite exercise that is also always a good ice breaker to get a group of students "out of the conventional observation mode of drawing."

Students are asked to find a collection of smallish objects like scissors, toilet brushes (unused), a shoe, a hole punch, or any of various tools. Gazzard is especially partial to things that have a variety of surfaces, shapes, materials, and interesting extensions into space, like coat hangers.

Next the class divides up into pairs, and each two partners seat themselves back to back. One student receives paper and something to draw with, while the other is blindfolded. The blindfolded student is given an object and asked to describe it in observational terms, without naming it or giving a clue to its function or use. For example: "It has a long bit sticking out that tapers toward the end and is about three centimeters ($1\frac{1}{4}$ inches) at the beginning and tapers to two centimeters ($\frac{3}{4}$ inch)." The description may include any facet of the object but must not mention anything that points to or indicates its function.

The students who are not blindfolded then draw what is described to them without seeing the object or knowing what it is.

The exercise elicits all sorts of skills and brings home to both participants concepts of representation, observation, and description.

Afterward the students change places, and those who were formerly blindfolded get to do a drawing.

Working with a Restriction

Allen Topolski | *University of Rochester, Rochester, N.Y.*

Using the nondominant arm to respond visually to an unidentified smell.

Several assignments depend on limiting students in some way. Allen Topolski does this in an exercise that he often gives on the first day of class as a good ice breaker.

A very large piece of paper is laid on the floor (formed from sheets of roll paper taped together) measuring about 60" × 90". Students help each other tape sticks (1" × 1" × 30") to their nondominant arms. This restricts movement of both elbow and wrist. They are also given a second set of 30" sticks with a brush, marker, or large piece of charcoal taped to the end.

Next, students are asked to sample the aroma of an unidentified substance. Things like shaved crayons, vanilla extract, cocoa powder, suntan lotion, or WD-40 are put in paper bags held by the instructor so that the students can sniff the contents without seeing them. Now, using the sticks with drawing medium attached, and prompted by the smell of the unknown substance, students are asked to make a drawing, either representational or abstract. No further instruction is provided.

The discussion that follows centers on process and motivation. Students reflect on how smell prompts a visual response, usually based on memories of an event. In addition, they often recognize the value of working with an impairment and the importance of turning it around to work positively. This is very different from usual mark-making, in which the artist clearly seeks control.

The class discusses typical assumptions. For example, students usually draw with their nondominant (bound) hand and draw on the paper, even though no specific instructions were given to do so. The topic of space is also discussed — how, for example, students frequently claim a space and rarely go outside of it on

the paper or with their bodies. The class also talks about the perceived precious-ness of their work and the way they relate to their drawings. An example is the way students will go to great lengths not to step on the paper before or after it has been drawn upon.

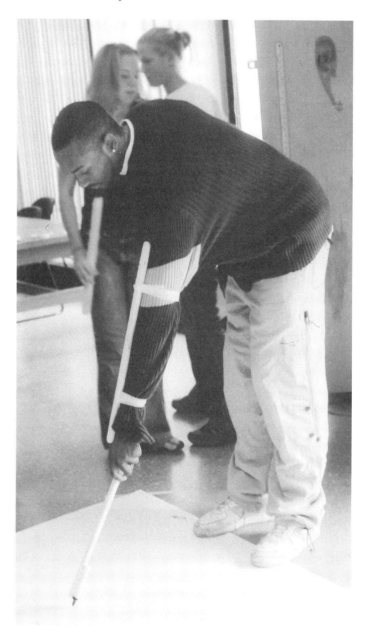

2 | *Self-Portraits*

MAKING A SELF-PORTRAIT sets up the most intimate relationship possible with a drawing. It places such high expectations on the outcome that many students are hopelessly frustrated by the experience. These assignments encourage them to think about self-portraits in ways that do not place the sitters in a one-to-one confrontation with themselves. By weaving in other demands and issues, these instructors have defined "self-portrait" more broadly. They suggest ways to achieve this objective through unexpected means and with a varied range of results.

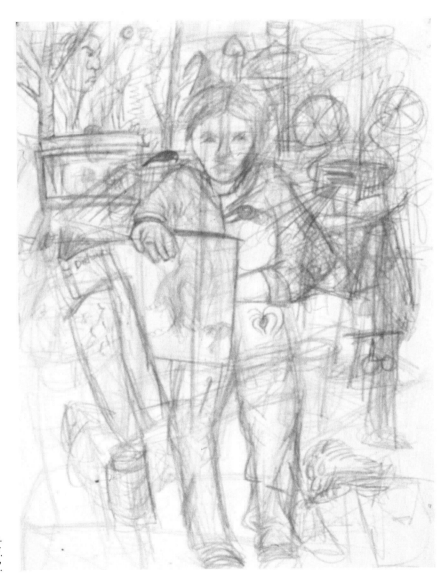

Wanda Gaston.
Self No Self.
Pencil. 23" x 18".

Self No Self

FRJE ECHEVERRIA | *University of Northern Iowa, Cedar Falls, Iowa*

Drawing from concurrent visual and mental events.

We all experience life on several levels at any given moment. Very frequently what we are looking at and what we are thinking about may seem to have only a tangential relationship or none at all. This is what frje echeverria imparts to his students when he says that "a drawing can be made from visual observation as well as from what we are aware of in our minds." To illustrate this, he makes a useful analogy with our experiences in an airport where there are arrivals and departures, and also fly-overs that do not land. He wants his students to think of their drawing in this way and allow it to evolve as their awareness changes. By focusing on the complexities of experience within a moment of time, the emphasis of the drawing is placed on inclusion and dynamic involvement rather than resolution or completion. In short, one drawing will record both visual and mental events.

> Start by using your eyes, and while looking in a window, draw your reflection as well as everything in the vicinity that you see, both through the glass and on its surface. Windows looking into a space slightly darker than the one you occupy tend to give the best reflections. As you draw from this view, use your mind to include also what you know about what you are drawing, what you imagine, and other things you sense or are thinking about, even if they are not directly connected to what you are doing and actually seeing

As his students draw, echeverria suggests that they linger over those issues that are of most interest.

Headless Self-Portraits

Robert Erickson | *University of Wisconsin–Stevens Point*

Which body parts could serve as a metaphor for yourself?

In different ways, many of the projects in this book attempt to bring out a personal vision. Robert Erickson's assignment directly addresses the issue of "Who am I?" While this is a cosmological question to which we all seek an answer, it is one that students in particular are frequently concerned with. Erickson asks students to think about themselves and what defines them at this point in their lives. If body parts could be used as a metaphor for themselves, which ones would they be? For most beginning students, this is the first time they have begun to think about questions of this nature.

"We begin by filling a large blackboard with an inventory of every possible body part—from legs to perspiration to, yes, even the soul," says Erickson. (As part of the introduction to this problem, he shows the work of Kiki Smith, a contemporary artist who uses the body as the subject of her work.) Students then copy the list into their notebooks to use as possible references in their drawing. This gives them a wider choice of possibilities for selecting body parts that might define them.

They expand the list by finding ten reference items showing the human body. These may range from anatomy books to glamour magazines, manuals on first aid to printouts from internet sites (although at least half of these should be other than internet-driven).

Students are then prepared to draw a self-portrait that does not show their head but tells something significant about themselves through the depiction of other parts of their body.[1]

Erickson's students also write a paper to chronicle how they developed their final drawing, starting from the initial brainstorming. Copies of these are handed out to all members of the class so that everybody can appreciate how all the drawings were created.

Ben Marheine.
Pencil and ink. 10" x 3".

Derek Ward.

Erased Self-Portrait

FRANK JACKSON | *Williams College, Williamstown, Mass.*

Working with a photocopy of your face.

Many artists have discovered that the copy machine can be a useful tool in the creation of imagery. Frank Jackson asks his students to begin by making several images of their faces on a copy machine.

> Students should try different expressions, vary the gesture, perhaps rearrange their hair, add a hand or jewelry. Working from a black surface and using the copies as a starting point, they try to replicate their image on a large scale by erasing back to reveal the tonal range that the paper offers.[2]
>
> There are several interesting aspects to this assignment. It is enormously informative for students to work reductively: that is, erasing back to reveal the form. It changes the hierarchical and linear manner that many students employ to draw objects and the figure. Instead of first using line to make an oval, then dividing the oval to create the correct proportions, and so forth, they use light and tone to resolve all areas at the same time. In addition, the image is also oddly out of focus until very late in the drawing's development, which seems to help control the self-conscious impulse of many beginning students to have it immediately "look like them." In an interesting visual "sidebar," the copies frequently have areas where the face has been flattened by the copy machine surface, adding further to the distortions.

Although this is a very simple and straightforward approach to making a drawing, the effect of the finished work is quite powerful. The drawings are not so much about techniques mastered and made visible; rather they are unique and personal expressions that balance the silliness of a photocopy of oneself with the melancholy evident in portraits coming out of or going into darkness.

Shelf Portrait

MARY FRISBEE JOHNSON | *University of Northern Iowa, Cedar Falls, Iowa*

Objects symbolize the things, places, people, and events of your life.

Many of us have had the experience of looking at someone's bookshelves or possessions to gain some insight into that person. Mary Frisbee Johnson asks her students to do a large drawing of a set of shelves, or a closet or cupboard full of shelves, on which are placed objects symbolizing things, places, people, and events from their autobiographies. The correct use of perspective in drawing the shelves and objects is also a major goal.

Kristine M. Hile. Self-Portrait. *Charcoal.*

Your assignment is to sketch the shelves filled up with objects that represent chapters from your life. The point is to let the objects tell the viewer about your life events.

Begin by thinking of each shelf separately, composing the objects carefully in each space. Then think of the overall composition, positioning objects to tie the whole together. After making small preparatory drawings, work big and fill up the space available to you on the shelves to make a rich, full-value drawing of complexity and interest to your viewer. You may work with odd scale relationships (your mother sitting in a rocker on a shelf transformed into her living room) or fairly realistic relationships (your mother's framed picture sitting on the shelf next to your dried-out prom corsage). If Daytona Beach is your favorite place, you could represent it with a postcard and a seashell, or you could simply make one shelf into a deep-space landscape; as an artist you can manipulate space in any way you want. Part of the problem is to depict your objects in as witty and intelligent a way as possible.

Alter Ego Drawing

Martin Kruck | *New Jersey City University, Jersey City, N.J.*

If you could be anyone else, who would it be?

Martin Kruck is interested in having his students extend the idea of making a portrait so that it begins to "question the nature of representation and the cultural signs that define identities." So he asks:

> If you could be anyone else, who would it be? Is your alter ego someone already famous, ordinary, or someone infamous? Would you adopt the persona of a historical figure, a character from mythology or fiction, or someone from everyday life in a different profession? Would you change genders or simply your wardrobe? We have all identified with other personalities. You will describe yourself as your alter ego in a drawing.
>
> Consider the outward signs that define a person. This may involve confronting and exposing issues of cultural stereotyping. How do we recognize each other? How do we recognize ourselves if pretending to be someone else?
>
> Research the style of clothing, hair, makeup, stature, and environment typically associated with your alter ego. Use this information to gather costuming and props for your drawing. Set up your drawing area with a full-length mirror and appropriate drawing materials. The most effective drawings will be completed as accurate portrait renderings.

The finished work will provide an important opportunity to consider meaning in representational drawing. If it is done in a classroom setting, this opportunity will also arise as students come to class dressed as their alter egos, challenging outward perceptions as to how social identities are constructed.[3]

Leandro Flaherty. Alter Ego as Caravaggio.

Collage Self-Portrait

SUSAN MORRISON | *University of Wisconsin–Stevens Point*

Creating a new image with fragments of your own old drawings.

Doing a self-portrait generally requires the most probing exploration of self and is therefore one of the most terrifying experiences for students. Susan Morrison has devised an assignment that builds the image from very familiar materials. She reminds her classes that drawing one's self-portrait has always been a major concern of artists; those of Dürer and Rembrandt surely come to mind.

Start by assembling several old drawings that you wouldn't mind ripping up. The subjects may be anything, drawn in any medium, color or black and white. You may also do studies of various subjects solely for the purpose of tearing them into pieces for this collage.[4] It is important, however, that you use your own drawings, because of their personal relation to you. This process is, incidentally, a great way to recycle drawings you like parts of, though perhaps they did not work as a whole.

Now you are ready to begin. In this project you won't be giving us just a surface description of yourself but rather an account of who you are. Draw into and over the pieces with any medium. The collaged fragments provide tone, color, and shape, and often juxtapose various images that suggest different meanings.

Work the collage and the drawing simultaneously. The portrait should fill the entire page, but keep in mind that hair and neck are secondary considerations. One or both hands may be included if they add to the expressiveness of the face. Negative space may be used as necessary.

John-David Gerard.
Collage Self-Portrait.

Shawn Stenberg.
Self-Portrait.

Self-Portrait in the Manner of Arcimboldo

PATRICK SCHMIDT | *Washington and Jefferson College, Washington, Pa.*

Your face composed of various objects, natural or man-made.

Several projects in this book are based on ideas closely associated with well-known artists. Patrick Schmidt feels that an interesting way to approach doing a self-portrait is in the style of the Italian painter Giuseppe Arcimboldo (1527–1593). Arcimboldo created portraits composed of a category of objects such as fruits, vegetables, flowers, or small animals. His influence is clearly evident in the work of twentieth-century surrealists such as Max Ernst, René Magritte, and Salvador Dalí.

First find a nonmirrored reflective surface such as those on aluminum cans, metal serving trays, and stainless steel appliances. This surface will distort your face but still allow you to see the basic shapes. It will help you to move away from the burden of having to "look like."

Draw the contoured lines and abstract shapes within your face. Then choose a theme and make a list of real objects relating to that theme that could replace the contoured lines and abstract shapes you have drawn. For example, if you enjoy gardening, you might use a hoe, a watering can, seed packets, flowers, vegetables, and the like, to create your self-portrait. By generating a list of twenty to thirty objects, you should have a sufficient variety of shapes to choose from.

After thinking through which objects might fit, gather the actual pieces to draw from. The objects you choose and the way you place them together will determine the self-identity you convey to the viewer. Remember also to develop the background so that it relates to the portrait.

Self-Portrait as an Object

VICTORIA STAR VARNER | *Southwestern University, Georgetown, Tex.*

The many choices and skills involved in drawing an object that will represent yourself.

There seem to be limitless possibilities for ways to make self-portraits. In Victoria Star Varner's version, students are asked to select an object to represent themselves.[5]

What potential readings might arise from your decision? Consider the aesthetic, psychological, sociological, and political implications of your choice, and how you will enhance or minimize these. Of what significance is the gender, ethnicity, race, sexual orientation, age, profession, etc., of the subject in the potential reading of the work by its audience? Might expected cultural interpretations be undermined by the artist or be used as a clever device for revealing social or political inequities or problems? How might others interpret your choice of an object without knowing your identity?

Can the size of the object and its scale in the drawing be used metaphorically? What kinds of questions arise about the ostensible subject (the object) as a consequence of its aesthetic and/or formal interpretation? How might you pose complicated questions with multiple potential readings?

Consider the power of composition to affect meaning. How will you design the interaction of space and object? Will the space press against the object uncomfortably, obscure it, support it, surround it, caress it? Will your sensation of touch be suggested by your interpretation of the object, by its space and texture? Consider the mass and weight of the object and its space, and how you might manipulate their appearance. What will the illusion of light and darkness, motion or stasis, in the drawing suggest?

Think about how artists have invested or divested objects of cultural meaning in the past. (Consider Edward Weston's photographs of green peppers or Jim Dine's series about a bathrobe.) What might the accumulation of your personal choices suggest in the drawing?

Nicole Hilborne.
Self-Portrait as an Object.
Charcoal and Conté. 103" x 42".

3 | *Drawing from the Model*

\mathcal{F}IGURE DRAWING is the most traditional of subjects. Whole courses are devoted exclusively to its study. While some instructors find the straightforward consideration of the subject sufficiently interesting for an entire semester, others may appreciate the variants suggested here. These assignments suggest that much can be learned from more unconventional approaches, which will enable students to see aspects of the model in ways not previously apparent.

Drawing the Figure Concealed and Revealed

Nancy Eisenfeld | *Quinnipiac University, Hamden, Conn.*

The model wears a stretch fabric garment to enhance the impression of movement.

Here is one of those assignments that are just plain fun. Nancy Eisenfeld considers that gesture is a concept that can be taught by preparing students to feel activity and movement in their own bodies. The inspiration for the project came from Martha Graham's dance performances in which she used a stretch fabric material to cover her body. "The covering limited her movement and yet seemed to enhance and clarify it as well," says Eisenfeld. "Graham's movements were very active, gestural, and elemental." Eisenfeld's project requires putting a tube of stretch fabric over the model to emphasize movement. This allows students to see and draw large actions and avoid distracting detail. The vision is reminiscent of work by two early twentieth century artists: Ernst Barlach's sculpture and Käthe Kollwitz's drawings and prints.

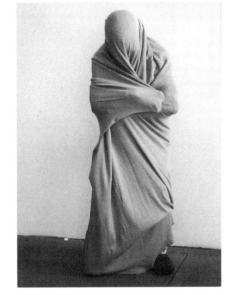

First students are asked to clap, stomp on the ground with one foot, and jump. They are then asked to draw these movements without reference to a figure. Line quality, pressure change, and rhythmic marks describe the sensory perceptions. The objective is to interpret the meeting of two forms, such as the sting of clapping hands or contact between the foot or feet and the ground.

Then she asks the model to put on the stretch bag.[1] On a large sheet, and with a broad drawing medium, students are asked

to work with a continuously roaming line to explore the perimeters and interior creases of the stretch material as it wraps around the figure. These lines should be quick and continuous, as though weaving around and through the forms.

Later the bag is removed from the figure and the model continues to hold the same pose. The drawing of the model is superimposed over the bag pose and may be drawn in another color. Elimination of detail is important. Finally the bag is put back on the figure and the drawing is redefined. The result is a drawing in process, where energy and layering of physical and visual information are apparent.

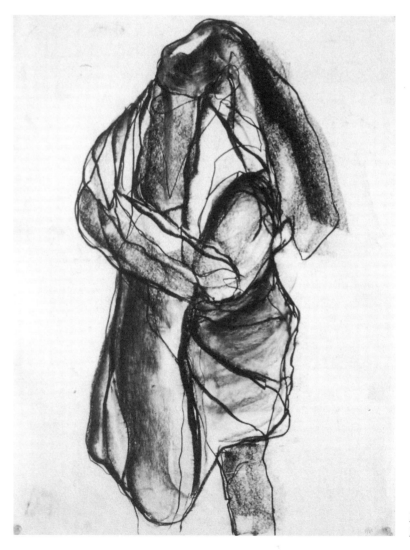

Drawing by Karen Orzack-Moore.

Figure Drawing without a Live Model

CHRISTINA OLSON SPIESEL | *Yale University, New Haven, Conn.*

Make your own model from assembled objects.

Everyone who has taught or studied life drawing remembers a day when the model failed to show up. While this assignment does not provide an instantaneous solution to the problem, it does speak ingeniously to many situations in want of a live model. Christina Olson Spiesel says:

> Artists wanting to work from the figure often run up against a number of obstacles: budgetary constraints, their significant others get tired of posing, their interest in their mirror image wanes. Sharing a model all the time can get tiresome; the weather gets bad and it's hard to find people lounging in public places like parks or beaches. Here is a suggestion for another approach: make a model. This model will be infinitely patient and can be available to pose at will as long as there is space to house it. The task of making the model is in itself creative and requires the conceptual work that constructing any setup demands. This is a twofold problem: to project human presence onto inanimate objects and then to make a drawing that is compelling to a viewer.
>
> While it would be possible to make a "figure" by putting features on a single object—say a vase or a chair—this is the least interesting way to go about it and one that won't really challenge the artist to go further, to ask many questions. What are the shapes and proportions that remind one of a person? How can youth

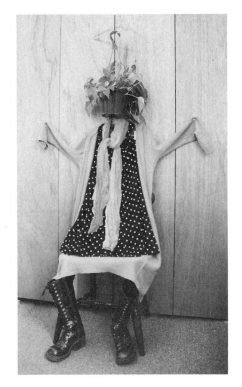

or age be suggested? Is the model male or female? What is its posture and gesture? Does this figure have weight? If composed of several elements, can the student subtly adjust those elements so that, as with a live model, the pose can change? Is the setup sufficiently complex so that it will compel the student to return to the model repeatedly, finding more, not less, metaphor? In looking at numerous attempts evidenced in a series of drawings, what happens when more or less emphasis is added to the human aspects of the setup? Can it be made to flicker between figure and still life? How does the setting—its scale and detail—affect the reading of the figure? Lacking human anatomy, what details make the drawing convincing? One hopes that this construction will become a familiar, engendering many drawings, not just one, and the occasion for dialogue and reflection between student artists and their teacher.

Drawing by Dora Malech. Figure Study.

Reportage

JANE STANTON | *University of Derby, Derby, England*

A *series of figure drawings that comment on real events.*

Completing a series of drawings on a subject requires a special outlook and sustained concentration. Jane Stanton's assignment provides the framework for this valuable experience. She asks students to imagine they are being commissioned by a quality magazine to go out into the field and produce a series of drawings that comment on how people in contemporary society spend their free time.[2] It gets them to think about their own personal agenda and encourages them to organize themselves in response to a real event.

Choose one leisure pursuit, hobby, or pastime that fascinates, amuses, shocks, or impresses you. These might include (but are not limited to) polo playing, pigeon racing, flower shows, darts competitions, Sunday soccer, pony clubs, and so on. Think of all the possibilities that might particularly reflect the national character. Approach the subject of your choice using your own personal insight and response. Start by investigating several subjects, and consider the following factors.

How practical is it to get access to your subject? If the activity takes place in extreme circumstances, is it possible to draw there? Does it lend itself to this kind of pictorial treatment, or might it be too dull and/or repetitive?

Make sure that your presence is welcome and obtain full permission. It's a good idea to take along some pieces from your portfolio to show people what you do. Your subject should provide you with a substantial body of work out of which will emerge your final choice of images in either black and white or color. What do you have to say and how will you tell your story visually?[3]

Helen Golding.

Tiffany Hamilton.

Drawing with Model and Projection

GELSY VERNA | *University of Wisconsin–Madison*

Slides projected onto the model create interesting effects.

Slides are part and parcel of teaching both art and art history. Most teachers have at times accidentally projected an image onto a surface other than the screen, occasionally to very interesting effect. Gelsy Verna has taken advantage of this phenomenon in her assignment. She says:

> The model takes a pose and slides are projected onto him or her until the class agrees that an interesting juxtaposition has been found. If students are doing this assignment for the first time, I use one machine and project abstract images by artists such as Franz Kline, Kenneth Noland, and Willem de Kooning. The way the colors and lines of these artists move over the model's body is sufficiently challenging.
>
> With more experienced students, I may use two projectors, each set to a different focus. The projected images are by such figurative artists as Donald Baechler, Kerry James, Francesco Clemente, Susan Rothenberg, Jim Nutt, Ray Yoshida, Roy Lichtenstein, Philip Pearlstein, Jonathan Lasker, Henri Matisse, and Adolph Gottlieb. The pose of the live model then appears coupled with figures in the painting.
>
> Students are asked to draw from what they see. They should consider the ways in which the projected image and model affect each other. In general the juxtaposition creates the possibility for new interpretations of the pose. The projection can be set to make it appear as though the model were interacting directly with it. Students may decide to draw the figure based on the stylistic features of the projected image. The projection may even be drawn to look like tattoos on the model's body.
>
> The setup also provides an opportunity for creating a background that is different from that of the usual classroom. A shadow is always present, but it doesn't have to be included in the drawing. If it is, it might be represented by colors other than black or gray.

4 | *Traditional Issues Reconsidered*

MOST INSTRUCTORS ARE aware that what was the art of the moment at the beginning of their careers has changed dramatically over time and promises to continue evolving. Yet no matter what the momentary shifts in art may be, there remains a consensus among art instructors that certain studies continue to be useful. Readers will recognize the traditional origins implicit in this group of assignments, but will also appreciate the novel directions given to them by their authors.

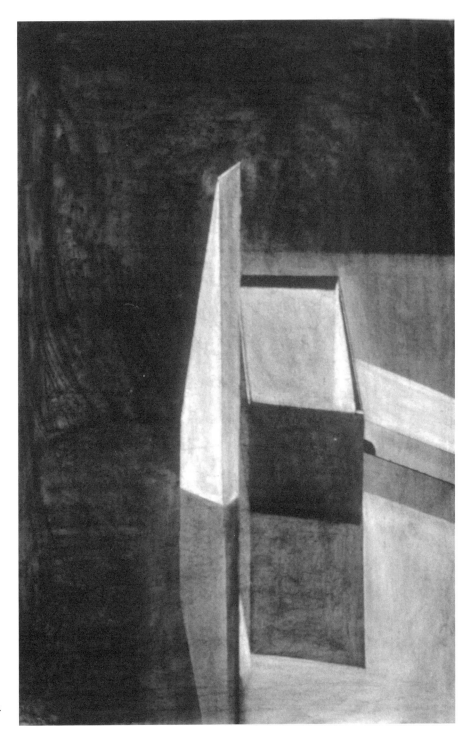

Jonathan Hollander.
Floor Still Life.

Constructing the Edge

Gerald Auten | *Dartmouth College, Hanover, N.H.*

Complex drawings of simple objects.

Depending on how they are used, simple objects can sometimes lead to remarkably sophisticated compositions. Gerald Auten describes his assignment as follows:

> I place a triangular wood shape (such as a doorstop) upright in the center of the studio's waxed black vinyl floor.[1] Students blacken their paper with charcoal and then erase to create the shape of the triangle and use the edge of a piece of paper to form the boundary between the object and the floor on the drawing. I have them notice the reflection of the triangle in the floor and any shadows that may be cast as well. The drawing has now doubled in complexity.
>
> Next I add a white box (usually the size of a pencil box) alongside the triangle and have the students construct this form using the same method. They erase or smudge to create the value relationships occurring at each edge of the white box and its relationship to the floor. The box also casts a reflection and a shadow. At this point, the students begin to see mistakes they have made in drawing the original triangle and make adjustments using the edge of the paper and their erasers, a paper towel, or their charcoal. They modify not only the dimensions of the objects, but also the dimensions and values of the reflections and shadows.
>
> Finally I put a black object on the floor, usually something longer than the white box. Then the students see that the floor isn't as black as the object just added, and they make more adjustments accordingly. The ground plane is now convincing and solid, and the drawings are complex and shimmer with light.

On Reflection

REBECCA BROOKS | *University of Texas at Austin*

A *clear or white still life allows you to concentrate on light reflection.*

As with a number of other projects in this book, the value of Rebecca Brooks's assignment comes from concentrating on a visual event that is common but too little noticed. "While most students are fairly comfortable rendering shadow values," she says, "frequently they are not given similar opportunities to work in reverse—with light reflection. By eliminating color, this drawing assignment allows students to concentrate on direct and indirect light reflection and observe how light, when it strikes various surfaces, from metallic to transparent, is altered in value and intensity." The assignment is a companion to a similar problem given in photography classes.

The subject matter needed for this project should include a still life consisting of a number of white, reflective (silver or chrome-like) and transparent objects.

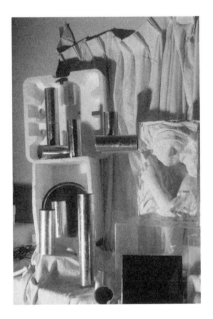

Some likely components are Styrofoam packing pieces, white fabric (such as sheets and curtains), white dishes, acrylic plastic boxes, plaster castings, and foil-wrapped forms. With this collection illuminated from one or two directions by spotlights, a clear and/or white still life is created. The complex illumination of these forms teaches students to observe and render very subtle differences in light and refines their perception of value.

Students position themselves so that they are able to observe a portion of the still life that includes at least three different surface qualities. A small viewfinder (a slide mount or one constructed from a 3" × 5" card) is help-

42

ful to isolate an area of the still life that offers a wide range of values and an interesting composition. Depending on the area selected, the image may be representational or abstract.

Brooks suggests that the drawing should be done on good-quality black paper with a white drawing medium such as white Conté crayon. Erasers and blending tools are useful as well. Once the basic white drawing is complete, students may want to enhance the depth and range of values by adding darks to certain areas.

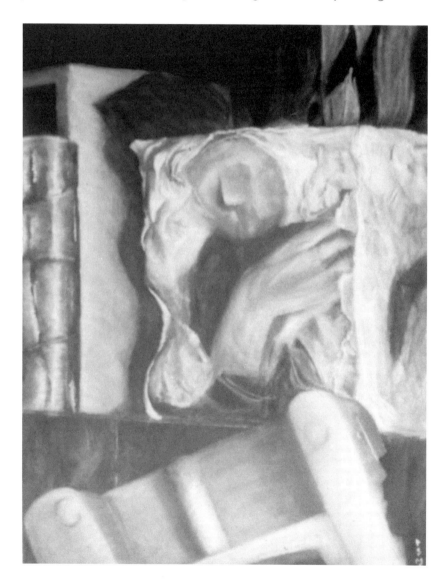

Drawing by Peter McGuire. Still Life.

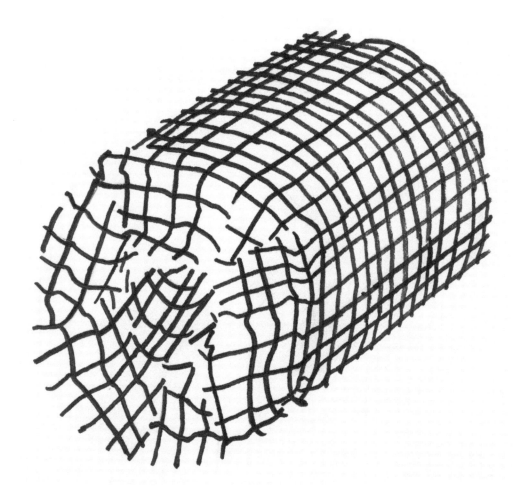

Sally M. Day. Wrapping Paper.

Wrapping Contours

CHRIS DAUBERT | *Sacramento City College, Sacramento, Calif.*

A novel way of rendering a three-dimensional surface.

In this exercise Chris Daubert presents a new take on a traditional concept: volumetric contour (using line to describe volume). His assignment illustrates how a change in the direction of parallel lines produces the illusion of a contoured three-dimensional surface. Initially students often fail to understand the reason for learning how to draw this way. So, as part of his introduction to the problem, Daubert passes out enlarged photocopies of U.S. currency, showing the line grids that describe the presidents' faces.

To begin, each student receives the largest size paper available from the copy machine, with one side printed with black parallel lines spaced ½ inch apart, while the other side has a ½-inch grid. The thickness of the lines corresponds to that made by a medium felt-pen marker.[2] For more advanced students, striped and checked fabrics would also work, but may lead to an exercise so interestingly complicated that it is nearly impossible to do."

Using this sheet of paper like gift wrap, each student encloses a simple, familiar object in it. Daubert says, "I try not to offer suggestions, giving students the power of choice and discovery, but some ideas might be a roll of toilet paper (as in the accompanying illustration), coffee cups and mugs, water glasses, a Coke bottle, some cell phones and TV remote controls, a ladle or wooden spoon, an open hand, a bar of soap, or headphones."

Students may choose which side of the paper they prefer, the straight lines or the grid. As they draw following the lines, the contours of the form will become apparent. The drawing is life-size so that the thickness of the lines is consistent with both the printed lines and the size of the wrapped object.

"During the critique," says Daubert, "we look to see whether the form of the object is believably rendered, and we try to guess what the object is."

You Are a Mouse

LAURIE FENDRICH | *Hofstra University, Long Island, N.Y.*

Perspective drawing with a twist.

Sometimes the most ordinary things take on interest because they are seen from an unusual and unexpected perspective. Laurie Fendrich invites us to share a view of the world well known to Stuart Little:

> You are a mouse sitting somewhere on top of a desk, surrounded by stuff. Your viewpoint is obviously very low. You may be looking toward the corner of the desk (two-point perspective) or toward the far edge (one-point perspective)—it's up to you. The desk may be a mess: books (stacked and falling over, open and closed), eyeglasses, pencils, pens, brushes, a stapler, a headset, a magnifying glass, scissors. . . . Perhaps a bottle of ink or a cup of coffee has spilled. On the other hand, the desk may belong to a very organized person, with things lined up neatly, parallel to one another. Use your imagination, but choose objects that lend themselves to perspective drawing, as opposed to those primarily defined by their texture or organic form.
>
> Draw with a light gestural line, but be extremely accurate about establishing the low eye level and vanishing points. Many of the objects on the desk will appear to be very large from your viewpoint.

While she permits her students to use a straight edge to help in the construction of accurate perspective, Fendrich cautions them to avoid using it literally to draw with. "And don't forget that you are a mouse!"

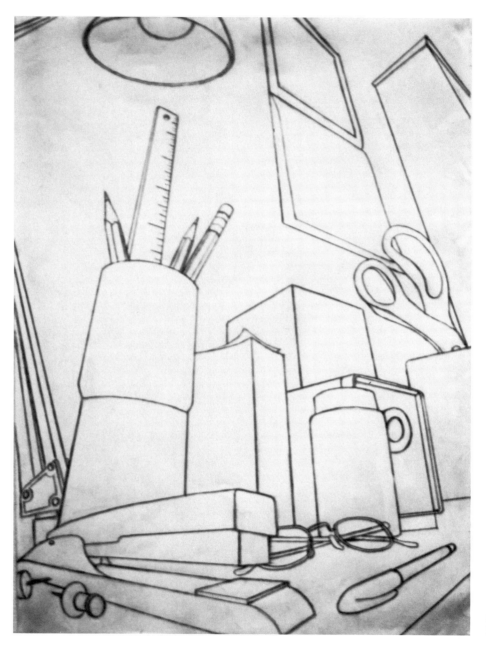

Amanda Hoeffner.
From a Mouse's Perspective.

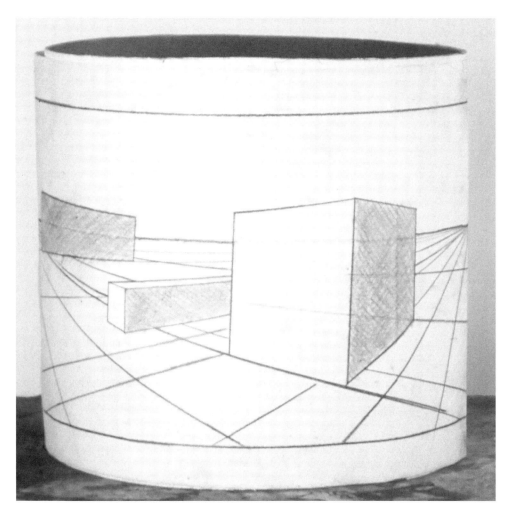

Hugo Vial.

Tube Drawing

DEWITT GODFREY | *Amherst College, Amherst, Mass.*

Drawing on a tube produces multiple points of view.

DeWitt Godfrey's project is about multiple points of view. With a drawing made on a tube, there cannot be any single point of view such as many projective pictorial systems depend on. You must construct a pictorial system that has a dynamic premise, one that may have moments of rest but also must have elements that "get us around the tube."

Using a 10" to 16"-inch-diameter Sonotube,[3] prepare the surface for drawing.[4] The simplest way to think of the tube is as a sheet of paper joined at two ends. The space/surface of the drawing is no longer bounded on four sides but two, top and bottom. The drawing you construct for this project must acknowledge the continuous horizontal surface of the tube; perhaps as an endless loop, depicting some narrative structure (using discrete cells) or other. The format of the tube makes interesting demands on our notions and expectations of pictorial space.

You might incorporate ideas of projected pictorial space such as the flat, hierarchical space of Byzantine art, the deeply modeled space of Caravaggio, or the strong perspectival spaces of the High Renaissance. The space of the tube can be treated vertically as one surface, divided into bands of spaces or shown as spiraling intervals, as in the famous monument Trajan's Column.[5] Other important models exist in such diverse forms as Greek Attic vessels, the generative patterns of M. C. Escher, the structure of films, and contemporary comic books and graphic novels. All these examples illustrate the vastly different visual solutions for discrete spaces provided by this assignment.

Arbitrary Color

Janis Goodman | *for the Corcoran College of Art and Design, Washington, D.C.*

Making color drawing a positive experience.

Many instructors feel that teaching color is difficult, and students also question their ability to use it well. Janis Goodman and her faculty have developed a project that is certain to make using color a positive experience. Goodman says, "This project encourages students to work with a wide range of color using an approach that is engaging and dynamic. It allows them to see the exciting results of mixing and layering color, even if they have not had any prior color experience. Our exercise may be used with any representational imagery (figure, still life, or landscape) as well as nonobjective subject matter."

To start with, choose a neutral color from a large box of colored drawing materials.[6] Use this color to block in and establish the entire composition by working with gestural and contour lines. Devote about 20 minutes to this step.

Then take each color in sequence from the box and draw with it for 30 seconds. For the next 45 minutes, change colors in the same order every 30 seconds without deliberation or hesitation. Work simultaneously in the background, foreground, and middle ground, filling in shapes, identifying value variation, and redefining lines and forms. The entire surface area of the drawing should be explored and covered.

Finally, take an 10 additional minutes to finish up the drawing.

Sarah McLaughlin.
Arbitrary Color. *Oil pastel. 18" x 24".*

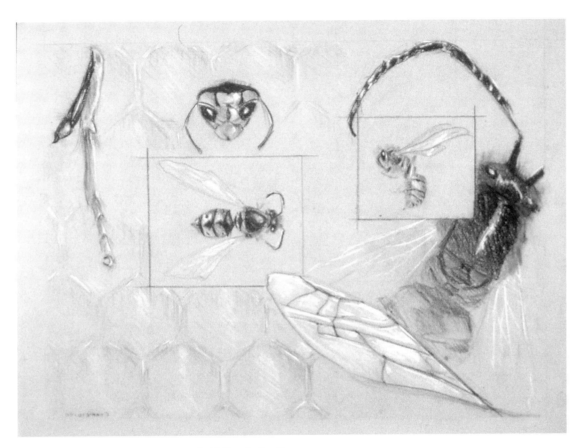

Corry Kanzenberg. Visual Dissection of a Yellow Jacket Bee.
Black, white, brown, and sanguine Conté on gray paper. 12½" x 10½".

Visual Dissection of an Organic Object

JEREMIAH PATTERSON | *Hartford Art School, Hartford, Conn.*

Studying the minute details of a natural form.

The intent of some assignments is to grasp the totality of a subject and ignore the particulars. Jeremiah Patterson directs his students to study the minute details that make one object different from all others of its type.

> Find an interesting organic subject, larger than a golf ball and smaller than a basketball. It should have an intriguing shape made of several parts and lend itself to being studied. You may want to gather two examples of your subject, which will enable you to pull apart and dissect one while leaving the other whole as a reference to the object's complete shape. Examples of items that work well are a pine cone, a gourd, flowers such as a lily, fruit, a horseshoe crab shell, a skull, large seed pods, or an ear of corn with its husk.
>
> In your sketchbook, make several "whole object" and "detail" studies until you begin to understand the object's unique characteristics. Direct illumination on your object will make its light and dark sides visible, assisting the development of its three-dimensional appearance. Dissect your object in a systematic way, and after each stage, make a drawing that records the new knowledge gained. When you have a good understanding of your object's "anatomy," begin your final drawing.[7]
>
> Compose your page in an interesting way by showing several views of your object, detailed observations of its parts, and drawings or diagrams that describe its construction. Create a visual flow through the whole page by analyzing shapes, building connections between parts, and trying to reconstruct the process of the dissection. Your composition should have at least one precise image of the entire object, and may also include diagrams details, parts of the object, and the way it looked in its various stages of dissection. Do not include any text; the viewer should be able to understand your organic object from the drawing alone.

Layered Landscape

Rob Stolzer | *University of Wisconsin–Stevens Point*

Creating space in a drawing, working with the foreground, middle ground, and background.

The problem of how to consider the space in a drawing is addressed in a distinctive way by Rob Stolzer:

The class meets in a wooded area on the outskirts of the campus. (In other environments, city buildings might be used or even a large collection of plants. I have also had students work on a very small plot of ground—say one square foot—and draw lying down. The layering of grasses, weeds, and nature's debris also offer a landscape scene.) Students scatter themselves in the woods, but within earshot of my voice. All of the students have compressed charcoal, Conté crayon, vine charcoal, and their newsprint pads. They are given five minutes to draw the scene in front of them—no other instructions. Then I talk to them about the spaces in their drawings, specifically the foreground, middle ground, and background.

For the next series of drawings, I ask the students to work on only one ground at a time, giving them various amounts of time on each ground. I assign the material to each ground, as well as the amount of time they have. Students are given some rough parameters regarding the foreground, middle ground, and background, but they need to decide where the grounds begin and end. They start their first drawings with the foreground space, and I purposely assign the "wrong" tones—lightest in the foreground and darkest in the background—to the drawings. Gestural energy is very important to this assignment, so I keep the working time in each ground very short in the beginning. The students start with 10–30 seconds in each ground, gradually working up to longer times.

We then switch the order of the space divisions so they start with the background. The students now use the "correct" tones to achieve atmospheric perspective: lightest medium in the background, next layering the middle-tone

medium in the middle ground, finally ending up with the darkest medium in the foreground. They are given the most time on these final drawings, but no drawing takes more than 15 minutes.

Lastly, we break out a few of the different drawings so they can see the difference in the spaces that they've created. Almost unanimously, they can see how much deeper the space is with the gradation of tones.[8]

Fumiko Amano.

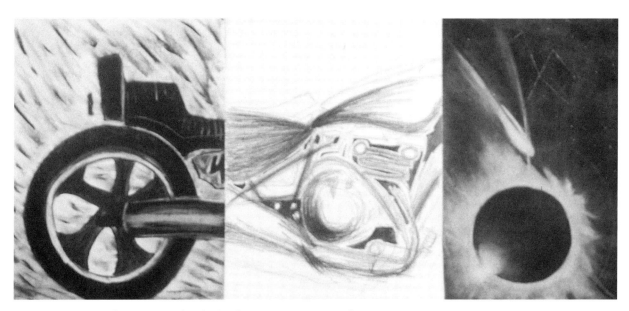

Kara Vosters, Hiroyoshi Katsuta, and Mike Crockett. Exquisite Motorcycle.

Exquisite Motorcycle

KRISTIN THIELKING | *University of Wisconsin–Stevens Point*

Precise drawing techniques are incorporated into a fun collective exercise with surprising results.

This exercise is fun to do and a reward for having mastered very precise drawing. Kristin Thielking says her students first spend a long time learning to meticulously draw a 1989 Kawasaki 454 Ltd.[9] After they have finished the detailed drawing of the motorcycle, they split up into groups of three or two, depending on the number of people in the class.

Each group makes a small sketch of the motorcycle divided up into three segments. They then line up three pieces of 18" × 24" or larger paper and put four small reference marks on them to indicate where the bike is divided. This is similar to the "exquisite corpse" technique of the surrealists, which produced a kind of collective collage of images.

Next the students draw front, middle, and back portions of the motorcycle, using the reference marks. (That is, each student draws one-third of the motorcycle.) One of these drawings must be made from strict observation. For example, a fantasy motorcycle may be made from closely observed objects such as bananas, light bulbs, or body parts, or it could be a real motorcycle. The second part should show the motorcycle using one of the techniques covered in class, such as reductive drawing, gesture, texture, cross-contour line, patterns, or positive/negative shapes. On the third sheet the motorcycle may be shown in whatever way the student chooses.

Each group should draw without any knowledge of what the other groups are doing. During the critique, all the drawings are put together for the first time to create three motorcycles. After spending so much time on the first painstaking drawing, students really know the subject and are able to be expressive and creative without losing the form of the bike, which is now imprinted on their brains. When students collaborate on this project, they seem to be more willing to take risks.

5 | *Space*

STUDENTS ARE TYPICALLY as aware of what they are drawing as they are oblivious to where that subject exists in space. And, as an extension of this issue, they are quite unaware of the enormous consequences their choice of placement in space will have on their subject. Perhaps it's no accident that issues of space occupy the largest section in this book.

Where the Floor Meets the Wall

Michael L. Aurbach | *Vanderbilt University, Nashville, Tenn.*

The choices involved in developing expressive pictorial space.

Michael Aurbach teaches his students that "drawing requires making choices and provides not only a powerful means for creating expressive space but also a system for controlling it." To achieve this end, he poses the following problem:

Students are asked to move themselves and their drawing benches against the walls of the room so that the center of the room is fairly empty. Instructor and students then fill the space by scattering plastic bottles, trash cans, sculpture bases, broken drawing benches, drawing props—anything they can see over (normally under 3 feet in height), though an occasional easel or something similar can be included. The students "enjoy the physicality of moving, even throwing things around," Aurbach reports.

The next step requires that students choose a section of the room roughly 15 feet wide directly across from where they plan to work. In effect they are selecting what they will draw. Aurbach then asks them to identify where the floor meets the wall across from their position. "Where they place that intersection provides a control and determines a lot about the drawing. Experimenting with its placement makes interesting things happen.[1] They also have to decide whether their drawing will be vertical or horizontal. "There's no wrong answer, but it does make them think about composition."

Once these limits have been imposed, students start drawing whatever lies within their 15-foot zone. Items on the wall such as an electrical socket, a ventilation cover, or a student drawing might be the first things they draw, followed probably by the student and drawing bench across the room from them. Things like cracks in the floors, stains, or even reflections help to serve as reference points and ways of gauging space. "When students are drawing objects across the room that are only a few inches from the wall I tell them to make those little

spaces tangible and palpable, as though a mouse could crawl through and behind them," says Aurbach. As their drawing progresses from the opposing wall back to themselves, students constantly add objects and observe the way space and scale play out. Aurbach observes that these changes may be quite dramatic depending upon where students initially placed the meeting of floor and wall. They also reinforce the fact that every object in the space relates to every other object and that what you see is not what you know.

Forms may be treated as solids, or, by layering contour drawings over each other, they may be seen as transparent objects. Both are equally good approaches.

This assignment may be repeated successfully. When students locate a new place where the floor meets the wall (or, one might say, where earth meets sky), they are struck by the changes in the way the pictorial space develops.

See page ii opposite the title page for another student's response to this exercise.

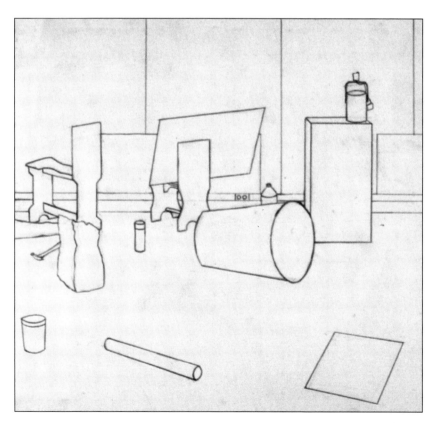

Sarah Savage. Pencil.
12½" x 12".

Seeing the World Differently

Marc Dennis | *Elmira College, Elmira, N.Y.*

Find new meaning by drawing something small and making it big.

Many instructors recognize that requiring a particular point of view enables students to see the world differently. Marc Dennis asks his class to greatly enlarge what they observe and thus find new meaning in it.

Draw anything that is small, even bordering on tiny (natural or man-made), and make it big. Magnify its detail in proportion to the enlargement. This enormous change of scale could make a 4' × 4' drawing of a wren's skull have the impact of a landscape or the austere quality of a steel-gray winter's sky. A 3' × 5' drawing of a portion of electric cord should have a serpentine mystery and the provocative nature of the unknown. As Henry Geldzahler noted, "The Pop artists' play with transformations of scale and interest in everyday objects and images isolated, typified, and intensified their subject matter."[2]

Allow the object you are drawing to fill your visual field and your whole consciousness. As you zoom in, you will notice surface details: small cracks, pocking, specks of dust, bumps, hair, and so on. Observe the highlights (glossy or matte), textures, and gradation of tones. While your drawing must be rendered in a representational and realistic manner, its completed state could very well border on abstraction. It must enable the viewer to identify the subject, but it should also hint at a metaphorical or symbolic reference.

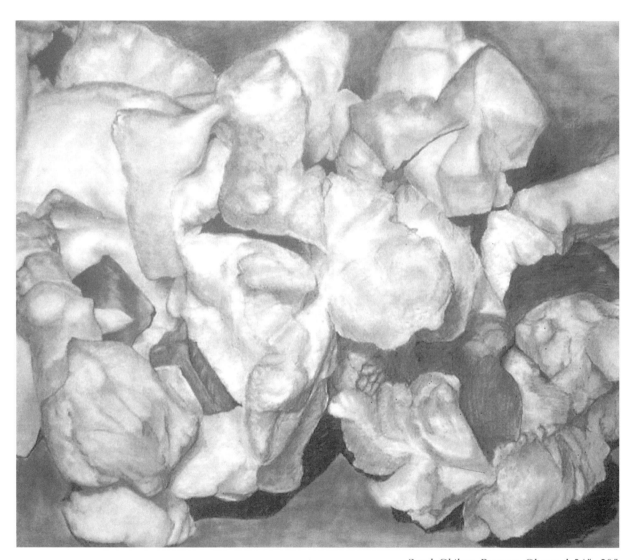

Sarah Chilson. Popcorn. *Charcoal. 24″ x 28″.*

Understanding Space and Scale

Barbara Grossman | *New York Studio School, New York, N.Y.*

How do space and scale affect each other?

Barbara Grossman's problem uses diminishing sizes of paper while remaining constant to the amount of information drawn. She says that the point of this lesson is to learn how to discover scale in changing sizes of paper and to understand how essential space is to the depiction of the motif.

This exercise is most effective after students have made *line* drawings from the subject for about 15–20 minutes while always remaining in the same position relative to the motif. The setup should be complex, and may or may not include a model. It is best not to tell students ahead of time what they are going to do, as they might anticipate the problems.

The first drawing should fill an 18" × 24" sheet of good drawing paper and take 20 minutes. When this drawing is complete, take a second identical piece of paper and tear it exactly in half. (The proportions of the paper will change slightly from drawing to drawing.)

On this half, draw the entire motif again, but in half the time (10 minutes).

Tear the remaining sheet in half and again draw the subject in half the time (5 minutes).

Now tear the next sheet in half again, and draw the same motif again in half the time (2½–3 minutes).

Tear the final sheet in half yet again, and draw the subject one last time (1–1½ minutes).

Use the final sheet to draw the setup from memory (2 minutes).

1

2

3

4

5

6

Dov Talpaz.

Hanging Out (In) the Wash

Nanci Erskine | *Colorado State University, Fort Collins, Colo.*

Drawing from within a draped environment.

It is a commonplace that where we stand in relation to what we are drawing makes all the difference. Part of the interest of Nanci Erskine's assignment is that her students work *inside* their drawing subject. She says, "This is quite different from their usual encounters with small-scale objects 'out there' which they circle around."

In a classroom from which all the furniture has been removed, twine is crisscrossed about 7 or 8 feet off the floor and connected to points all around the perimeter to create a spiderweb. Fabric[3] is then hung from the twine, leaving some openings, and crossing over to other connecting strings when possible. Nearby pieces may be tied together, or linked with pins, and some pieces may be on top of each other. Others will almost touch the floor or may drape in ways that allow one to see underneath to other forms. The result should be a kind of maze.

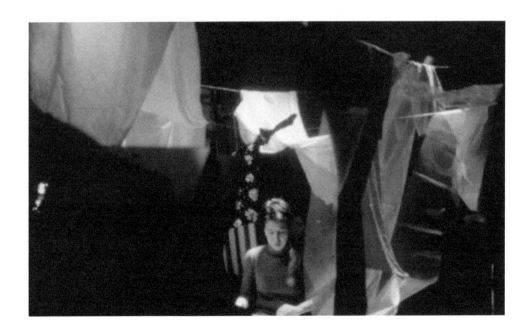

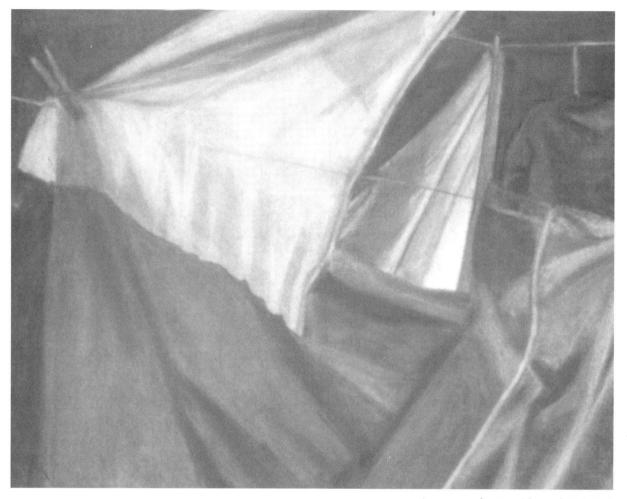

Anonymous drawing. Charcoal. 18" x 24".

"The magic happens when the spotlights are turned on and the rest of the room goes dark," Erskine says. "The lights create wonderful shadows on the floor, shapes on the different layers, and great gestural movements across the draped materials."[4]

Students are then invited to wander around and explore the environment. When they have found where they want to be they can drag in an easel or sit on the floor. Their drawings will be about the experience of this unusual space: "how it surrounds them, how they can see through the layers, how it looms above them, and how beautiful the floor becomes."

Thumbnail Drawings

SUSANNA HELLER | *State University of New York at Purchase*

Sketching the entire room within a small framed space.

Susanna Heller's project is about showing movement and the shifting ways we perceive and describe "place." It begins with a series of 30-second drawings in which the entire room must be described. "This becomes possible only through reinvention, by breaking rules both literally and metaphorically," she says.

Students start by drawing small frames of various shapes and sizes and then drawing within them. Warned that they will be unable to fit the whole room into the framed space, they have to work past the edges onto the rest of the paper. Some of the thumbnail variables: drawing within 1" squares, round frames, or diamond-shaped frames; moving students' location within the space; shifting their proximity to one another; following the instructor with their drawing tools and recording her movements on paper as she moves around the room; and so on. New variations can easily be added. Students discover that any seemingly neutral or uninteresting space may be turned into one that is rich and inspiring. They are encouraged to be curious, playful, wildly inventive, and to look at all the extremes of the room, including what is behind them. They must also consider their own size and density in relation to the space they are in. They must be harsh editors in order to perceive and portray the main "events" of the room.

The class discusses the difference between what we know about what we see, versus what we actually observe, and how our learned knowledge distorts our perception of reality. They talk about the room as a figure, and how these images are like environmental gesture drawings. Students then go on to 60- and 90-second drawings, up to 5-minute drawings.

"Subsequently I ask students to choose their favorite thumbnail drawing," says Heller. "They blow this up to a large-scale drawing (at least 10 feet wide), which

must cross at least two planes, therefore placing the work into real, three-dimensional space. Now they can see how the interpretive changes that occurred in the thumbnail drawings are still able to convincingly describe space and movement."

Justin McAllister.

The Clown Nose Project

Thomas Johannes | *Washington Studio School, Washington, D.C.*

Drawing not* things *but the relationships between things — drawing thoughts!

Thomas Johannes's project is concerned as much with the cerebral process involved in making a drawing as with the subsequent results. His assignment departs from the following statement:

> The three Pillars of Zen Buddhism are great faith, great doubt, and great determination. It is important to focus on how such a pairing of opposites might coexist in a useful way. Are not faith and doubt mutually exclusive? Does great determination somehow provide the cohesion?

"The opposition between faith and doubt and the driving mechanism of determination are very relevant to practice of art," says Johannes. "Working from observation, chasing after 'reality,' fleeting and ultimately unknowable, is nevertheless a process that creates reality (art). The process requires both tenacity and 'letting go' — things that one might think would cancel each other out; yet the product can be art or some 'higher' level of knowing that thumbs its existential nose at duality."

In the center of the volume of the studio, a bright red clown nose is suspended — the cheap foam toy-store type used for kids' parties. It is tethered to the ceiling with thin black thread, which might not be visible. It may be illuminated with a spotlight. Otherwise the studio is left in its usual, disorganized state.

The class is reminded that horizontals and verticals are notoriously unreliable

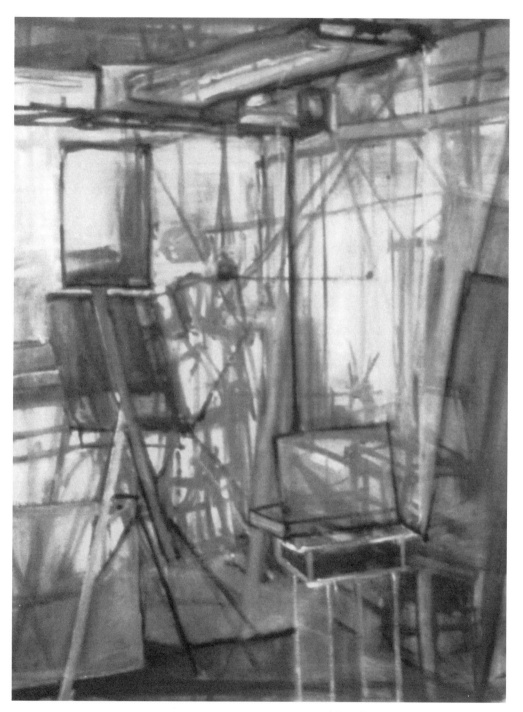

Aleksandra Holod. Clown Nose Project.

references. Horizontals not directly aligned with one's eye level will surely warp if one sees them empirically, refusing to exchange the definition of something with the experience of seeing it. Verticals will warp also unless they are aligned with one's nose before one's dominant eye.

Students are asked to perform the following thought experiment. Consider a typical street corner. Stand directly at the point of that corner on the curbstone and look up and out along one curb. Notice that it appears to be a vertical, one that will easily align with a pencil or finger held straight up beside your nose. The curbing and utility poles that rise up from it are, apparently, vertical. If you turn around, the other curb and related poles will appear vertical too.

So, if two different street curbs appear vertical, does that mean they are parallels? How can the reality of intersecting curbs be visually known as parallels? Obviously the whole conceit of mapping our experience of the three-dimensional world onto a flat, two-dimensional surface is flawed. It cannot be done. Then why do we try? At this point many students are troubled by doubt, while some appear to be darkly excited.

Beyond our discovery that the Cartesian geometry of absolute verticals and horizontals is an inconsistent and unreliable analogue for visual experience, we find that even our sense of what remains is relativistic and suspect. How can we draw from observation when we are uncertain of what observation means? Can we, for instance, know where something is located spatially relative to another thing? Can drawing be defined as a record of this effort? Might drawing from observation be about knowing and not knowing simultaneously?

Students position themselves with their easels and drawing boards as far from the clown nose as possible. They may draw or paint (using the fewest possible colors) schematically, not illustratively. "Drawing schematically" means that one is no longer drawing *things* but rather drawing the relationships between things, drawing thoughts! (Giacometti knew this.)

The objective is to draw the space around the clown nose from the floor directly underneath it to the ceiling directly above, and as far to the left and right as possible. It is frequently helpful to draw the empty space with imaginary tracking lines between objects or a vector from the clown nose to another object. A vertical or any other line may serve a double meaning: as an orthogonal projecting into space and as a line moving across the space parallel to the

viewer. The drawing begins to resemble a sort of scaffolding; one is building reality.

Eventually the marks and lines begin to suggest anomalous spatial meanings; this is the beginning of opposition for its own sake. Time is needed to assess the possibilities. If the project runs more than one day, no effort is made to keep things in the same place; the clown nose is the only constant, although it becomes as relative and arbitrary as everything else. *Faith, doubt, and determination.*

The Virtual Forest

CARRIE PATTERSON | *The College of William and Mary, Williamsburg, Va.*

A *"felt" spatial experience evoked by a maze of boards.*

There are many ways to teach perspective. Carrie Patterson's assignment explores a complex situation using only visual references. The classroom is set up like a forest with a maze of boards propped at an angle from the floor into the ceiling tiles and staggered thoroughout the space.[5] Easels and drawing horses are placed so that the boards will make visual intersections with objects in the room. Students will confront the boards from any location, resulting in drawings that have a sense of depth and a clear point of view.[6]

Prepare for the assignment by establishing a particular repetitive mark (aggressive and bold, or delicate and light), and stand at your easel looking straight ahead. Establish the closest thing to you without moving your head, and make a mark somewhere at the bottom of your page. Sight a line through the drawing board until it visually runs into something else. For example: "My drawing board is the first thing I see intersecting with the forest board directly in front of me." Make your mark at that intersection. The distance between your first mark and your second is the basic unit. This will control the scale.

Make a passageway of intersecting marks from the bottom of your page through the middle to the top edge. Work your way through the space to the farthest thing you see and upward to the ceiling and back to the closest thing to you. Do not move your head or your position. Move through the space from left to right, starting at the eye-level line; then do the same thing diagonally (top right to bottom left and top left to bottom right). Keep making passageways from edge to edge, using the same piece of paper.[7]

Do not start over; just erase and rework. During the last few minutes, rework the passageways that carve out the most space.

"I am amazed at the movement, life, and space captured in these drawings," says Patterson. "Some students who previously drew very mechanically open up and create drawings that are incredibly tactile. The most successful drawings don't depict objects at all, but instead are full of marks that demonstrate a beautiful 'felt' spatial experience."

Emily Gulick.

Make Space for Ideas

BARBARA PENN | *University of Arizona, Tucson, Ariz.*

Start your drawing with the ground or background.

Most instructors are familiar with certain routine decisions that a great many beginning students make. Barbara Penn addresses one that happens as students begin by drawing the subject first and forget about the ground or the space in which it "lives." By starting with space, or what is often called the "background," students recognize that it is important to the drawing to consider the world they are creating and its structure, before the objects or subject arrive in it."

Students are asked to bring in three images depicting space: one architectural, one from two-dimensional artwork, and another that seems unlike the first two. As pictures with space in magazines tend to appear flat, students should look for examples that have depth or a variety of values.

Then they turn the images upside down and "lift" or "borrow" the basic structures from one of these sources in combination with the two others. In other words, more than one type of space is made to combine with others, to create a collaged or assembled whole. Penn talks about "borrowing space" as a valid means of beginning a drawing without knowing exactly where it will take you or what it will end up looking like.

Once an interesting space has been laid out by using all three references, students put their initial sources away. They now take cues from their drawing and build the connections between the various spaces, continuing to create an interesting house or "background" for their ideas. The outcome may include portions that are architectural or contain two or more perspectives with other flatter depths.

"The variations are endless," Penn observes. "Sometimes I ask the students to make an arbitrary vertical or horizontal cut across their drawings and flip one part in the opposite direction. Then they are asked to go from there, taking it further in its new configuration. Often the spaces become more interesting than the solids. The spaces in combination with the solids tend to invite a more personal content (if encouraged)."

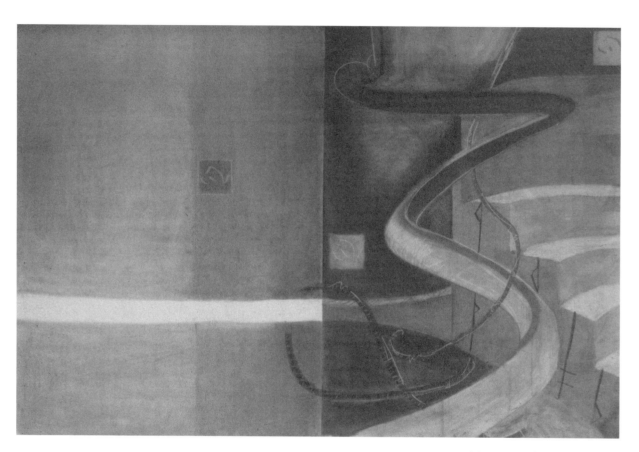

Margaret Ford. Room for Space.

Slice of Life

Ann Coddington Rast | *Parkland College, Champaign, Ill.*

Working with an unconventional format challenges our habitual visual assumptions.

One of the many issues that arise for beginning artists is the tendency to make certain automatic decisions without challenging these assumed constants. Ann Coddington Rast's assignment questions this tendency. "In drawing, we assume our images will exist in a conventional rectilinear format—a golden mean of sorts," she says. "Perhaps this 3:4 ratio approximates our visual field and seems somehow comfortable. We have become accustomed to viewing drawings with approximately this proportional relationship, and we're probably are a bit complacent when conceiving of an image—seeing this 18' × 24' frame floating in midair in front of us. This problem attempts to challenge our notion of format."

Cut out a viewfinder with a 1:4 or 1:5 relationship. Spend some time regarding your world through this window, both with a vertical and a horizontal orientation. Notice what is concealed, what is revealed. How do you feel when peering through it? Does it seem as though you are peeking through a keyhole? Are you frustrated by this visual limitation? How can the figure or portrait be interpreted through this window? Can you find a subject that seems comfortable in this format?

Try isolating a subject so that it becomes purely formal when viewed in such an extremely elongated format—where abstraction predominates over the referential subject. Consider subjects that exhibit vast spatial extremes—an interior and part of a window with a distant view, for example. Perhaps set up an image that can exist naturally within this frame. Question the eye level you select, the point of view, and whether the axes should be true horizontal and true vertical.

When you have decided on a subject and a rationale in your approach to this format, delineate the perimeter lightly on an 18' × 24' (or larger) piece of paper, paying attention to where you place your image on the paper. Interpret your subject using a full range of values.

Lin Lin. Stairs Panorama.

Field

Barbara Schwartz | *The School of Visual Arts, New York, N.Y.*

Repeating shape, pattern, and process.

Many students take a long time to realize that no matter what they are drawing, they must somehow deal with the entire sheet of paper. Barbara Schwartz says of her assignment that "the idea is to fill the paper with the repetition of some shape, pattern, process, which enables you and the viewer to become engrossed with surface changes. Recall how Jackson Pollock achieved his dense, animated paintings with bits of flung color."

Students may derive this "field" from a specific source such as ocean waves or an industrial grid. They may employ marks particular to something such as footprints or rubber stamps. "You could use a specific collage material like 1 inch pieces of tape, or a linear element like string which meanders across the paper," Schwartz suggests. "You might use hatching (like Giorgio Morandi), patterns in nature (like Leonardo da Vinci or Vincent Van Gogh), or even letter/number forms (like Jasper Johns)."

> Using a material and method of your choice, create a field on a large, square piece of paper. The larger the surface, the more it enables us to enter into it. Cover the entire surface. Your drawings will have marks on every bit of the paper. Consider your approach carefully. Do you start in the center and work your way out? Do you start at one edge and work across the surface, or jump from one area to another? Consider using a new tool or process. Choose something that will be enjoyable and challenging.[8]

At the end of the class, Schwartz displays works so as to form a collaborative "mosaic" drawing.

Kira Beougher.

A Journey through Light and Dark

JUDITH SCHWARZ | *York University, Toronto, Ont.*

Moving from observation to interpretation.

If asked to draw from observation, students often assume they have to adhere rigidly to what they see. Judith Schwarz's assignment makes them more aware of the possibilities for interpretation. It demonstrates the interplay between the real and the imaginary and emphasizes the artist's authority over the image.

Initially students draw from observation and develop eight or more views that construct a sequential passage from outdoors to indoors (or the reverse). Accurate observation of a significant place in the environment is important.

The first eight drawings provide sufficient choice for resolving the final five drawings. Concentrate on the structure, the underlying vertical, horizontal, and diagonal division of the picture plane, and eliminate unessential detail. To ensure a sense of movement through space, select views that make a strong transition from wide open space to middle ground to close-up space.

The concluding step is to create five or six drawings in class (away from the original drawing site) that emphasize interpretation. Each of these drawings should have something in it that connects it formally or symbolically to the next drawing. For instance, an object or texture may appear in several drawings, or an underlying structural rhythm may connect the whole sequence.

A journey through the environment consists of not only what you see (landscape, architecture, objects) but also what you sense and feel. Interpret the time of day and create a mood with the use of light and dark. How does the light shift from indoors to outdoors within your sequence? Is it bright or gloomy outside? Are the halogen lights turned on or off over your computer screen?

82

"The real journey taken here is through the creative process," says Schwarz. "At first, students look outside themselves for information and consider how that information can be translated into something beyond documentation. In the second part, they are asked to focus on how they can utilize their drawing skills to increase what they saw and felt. They are encouraged to rearrange the sequence, remove excess detail, invent light and dark for dramatic effect—in short, to use their imaginative and creative abilities to intensify the sensation of the real."

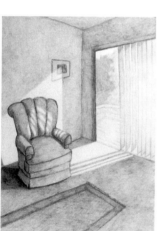

Jennifer Gal. A Journey through Light and Dark.

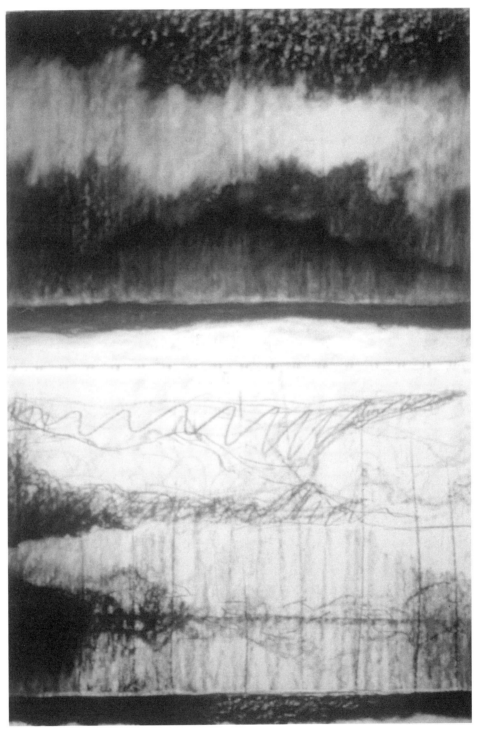

Craig Spurrier. Modeled Space Elements: Air.

Air

SUSANNE SLAVICK | *Carnegie Mellon University, Pittsburgh, Pa.*

Make the invisible visible.

Most assignments deal with very tangible matters. We are given certain steps to follow that will result in largely predictable ideas and drawings. Susanne Slavick wants her students to catch the barely visible, the evanescent, the ephemeral. She asks them, using tone, "to imagine making the air in any space visible."

> In this drawing, the tone should not represent a response to light and shadow; rather let it describe how you might imagine a vapor occupying a space. Would it cling to the ceiling, create auras around objects, settle in the corners, collect toward the openings, thin out or thicken toward the middle? What qualities might this atmospheric substance possess? Is it a fine mist? a coarse, gritty suspension? a humid or dry occurrence? Does it consist of dancing dust mites or a moping miasma? Does it absorb light or emit it? Is it governed by gravity or subject to any rules, physical or metaphysical?
>
> We are used to defining a space through its mental and physical limits. We look for boundaries, edges, the contrast of plane against plane. To break with habit, consider the definition of space through what occupies it, visualizing the volume contained. Allow the space to emerge through articulating what we normally might consider the void, a void that became pregnant with fullness. Let the invisible become visible.

Diorama

DAN SUTHERLAND | *University of Texas at Austin*

Building and drawing a model of an architectural interior.

There are many ways of investigating one's own surroundings, and Dan Sutherland's assignment offers an unusual approach.

Students are asked to bring materials to class from which they can build a model of an architectural interior. "I suggest the materials but not the subject," says Sutherland, "and usually do not explain what the model will represent, as this portion of the project is an exercise in memory and their imagination, not firsthand observation. On the day the materials are brought to class, I inform my students that they will be building a model, from memory, of a room they live in."

Materials could include (but are not limited to) a cardboard box 14"H × 14"W × 14"D or larger, cardboard, foam core, string, thread, scraps of colored paper, wire, glue, acrylic paint, clay, a polymer clay such as Sculpey, fabric, brushes, scissors, ruler, X-acto knife, pliers, and a hot glue gun. Often there is the need for technical troubleshooting for the models, as many students want to think of these models as permanent objects rather than visual props, or they lack the ability to create convincing three-dimensional space.

There are no rules concerning how the structures in the room are to be built. For example, all the furniture need not be proportional or made out of rectilinear materials. As the models are being built, Sutherland suggests that windows and doors could actually be made into light sources by cutting through the box. He has also had students fit small lighting sources or use their own lamps to exaggerate lighting effects after they knew more about the project. Some models have included images or details that exist outside the room and are visible through windows or doors.

The dioramas take at least one four-hour class to complete and are usually finished at home. At the next class, a series of drawings are begun to investigate the

miniature rooms. The size of the model affords a flexibility of vantage point that stimulates inventive compositions. The fact that the room and the model are the students' own promotes informed subjective technical manipulation of the drawings not found in their drawings of objects or scenarios to which they are emotionally or psychologically unconnected.

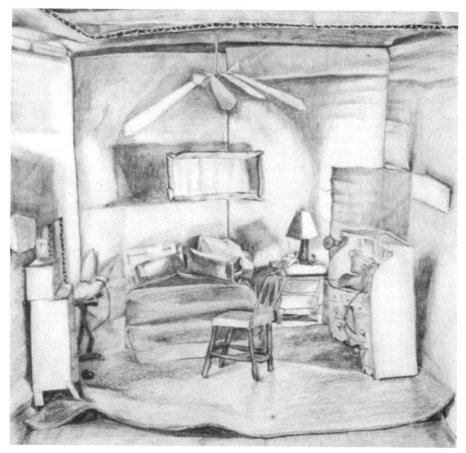

Christine B. Gray.
Bedroom Diorama.

"I have had great luck with a variation of this project when students make a diorama of an interior shown in an important painting," Sutherland adds. "This winds up being exciting because the students have to interpret an interpretation. Students look far more closely at the image because they have to build their model from it. They start noticing the very specific and subtle choices a mature artist makes while constructing a picture."

6 | *Line*

WHATEVER ELSE ONE may say about drawing, it is, more than anything else, about what line can do. Line is fundamental to drawing. Yet many students have little idea of the amazing forms line may take. This seemingly automatic and simple aspect of drawing is actually capable of playing the most amazing variety of roles in a composition. It is a tool with a fantastic ability to define almost anything and to change in an instant to quite another appearance with new descriptive abilities.

Drawings by Stephanie Signore.
Skating *(top) and*
Skating (Blindfolded).
Photographed by Bill Quinnell.

Skating

Robert Alberetti | *Western Connecticut State University, Danbury, Conn.*

An enjoyable way to bring more bodily movement into the act of drawing.

Instructors often look for ways to get their students to engage more of their arms (and perhaps even more of their bodies) as they draw. Robert Alberetti's assignment approaches this issue from a very enjoyable direction. He asks his students to imagine they are using their hand and drawing tool to skate across the paper.

> The drawing is best made on a large piece of paper laid on the floor. The sheet of paper is now transformed into a smooth ice pond and you are about to skate over its surface. The graceful motions of your skate leave incised marks on the ice identical to the marks you are making on your paper. The cool, crisp winter air infuses your body with vigor and vitality, and you find yourself pushing and gliding over the surface of the pond; at times you come to the edge of the pond (the edge of your paper), and you start anew. (If this exercise is given in a region where ice skating is not a common experience then the analogy could be made with inline skates.)
>
> After "skating" for something like twenty minutes, your lines accumulate and you find a weblike graphic diary of the areas where you have been. Try to cover the entire pond rather than limiting yourself to one small area. As in skating, you may find yourself drawing over your original path or close to it. Twist, turn, glide, stop short, accelerate, pirouette, jump—all those wonderful athletic techniques you have seen skaters do, you are able to perform.

With these words Alberetti suggests very effectively how differing speeds and directions can affect drawing.

This exercise may be done a second time, with students' eyes closed or blindfolded. The comparison between the two versions is inevitably revealing.

Line Collecting

Lisa Corinne Davis | *Yale University, New Haven, Conn.*

A *dynamic composition of linear objects and how they move in space.*

Line is probably closer to the essence of drawing than any other attribute. Lisa Corinne Davis's assignment is designed to have students "understand the importance of the descriptive roles of drawing media and how they inherently carry different references to ways we understand the world." Her students explore how to make a mark (or marks) characterize a linear object and its action in space.

Students bring at least five[1] linear objects to class such as pipes, ropes, branches, ribbon, bamboo, and rubber hoses. In a corner of the classroom, they create an installation of their objects: hanging things from the ceiling, stretching lines from wall to wall, draping lines over lines, or leaning them against a wall. They are asked to look through their viewfinders (made of an $8\frac{1}{2}"\times 11"$ piece of cardboard with a $4\frac{1}{2}"\times 6"$ window cut out) to see a cropped portion of the installation, and are then asked to analyze verbally the kinds of linear actions they see: "taut," "fast," "limp," "gnarly," "coiled." Next they are asked to find marks that simultaneously describe the objects and how they move through space.

In their sketchbooks or in drawing pads, students practice making marks that come as close as possible to describing the objects and their actions. The final descriptive marks are produced through the careful choice of medium (considering their different qualities and limitations) and the physical action used with it. (Drawing media may be traditional and beyond: charcoal, pencil, mascara, dirt, etc.) For example, describing a fast linear object such as a shiny pipe is different from looking at the interrupted surface of bamboo. They should not only describe the noun (what an object is) but also the verb (how that objects activates space).

The final large drawing is a dynamic composition of linear objects and how they move in space.

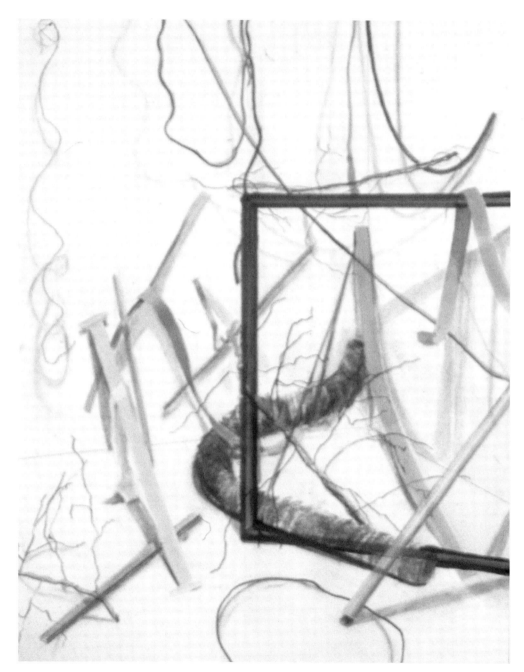

E. Eggebrecht. Mixed media.

Variations on a Theme

FREDERICK A. HOROWITZ | *Washtenaw Community College, Ann Arbor, Mich.*

Discovering how a simple line can be a launching point for an idea.

This exercise demonstrates to students that a simple line can hold the promise of a visual idea. In the process they become aware that drawings may develop intuitively, without outlines, and that accidents often lead to invention. It starts with making a list of line possibilities and then proceeds to the creation of a "paragraph" of lines. In the end these conventions are thrown away in favor of wild invention.

Bradd Griggs. Line Study.

List. The instructor draws a horizontal line (flexible-tip pens work well) across the top of a sheet of paper and then asks a student to draw a line just below it that is "different." "Different" means intrinsically different, not just a change in direction. (A curving line may have the same characteristics as a straight one.) Lines of a different character could be ones that are heavier or lighter, ones that fluctuate between light and dark, are thick and thin or shaky, made up of dots and dashes or other broken attributes A class of twenty-five students usually produces thirty to thirty-five lines in about 5 minutes.

Another student then draws a line that is unlike the first two. Continue down the page, with each student adding new and distinct lines until all of the possibilities seem exhausted. Next have each student fill a page with similarly varied lines.

Paragraphs. Students now choose from their list those lines they feel are most interesting or unusual and create a "paragraph" for each line. These should be about 3–4 inches long and drawn so they nearly touch, making blacks predominate on the page. This arrangement inevitably creates a texture.

Inventing. Students now ask themselves what would happen if the lines in their paragraphs were released from the constraints of horizontality. In this third drawing, they inevitably confront questions such as: Should the lines curve, make sharp angles, separate, draw closer together? How close, how far apart, how frequently should the changes occur? Should the lines unite, end in a dark mark, or fade out? Should the lines form a shape, rectangular or otherwise, single or a cluster, and if the latter, do they touch or overlap? If they are apart, how far apart? How do they relate to the edge of the page? How does the white of the page function—as leftover or another shape? Are accidental blobs part of the drawing?

Line Is Incisive

Alfred J. Quiroz | *University of Arizona, Tucson, Ariz.*

"Drawing" with a knife to create a stencil.

Many drawings are made with multiple instruments, but usually the mark-making tools predominate. In Alfred Quiroz's assignment, the knife takes precedence, and all the subsequent developments are derived from its trajectory. He says that the purpose of this assignment is to "create multiple images from a singular source, utilizing line as the primary element."

Using an X-acto knife only, carefully "draw" a figure (or still life or other subject), working with a contour approach. As an alternative, you may also create a value study of light and dark. This may mean cutting out the shadows only, or cutting out the lit areas of the figure. Doing the entire figure or a torso study, or both, is an option. You will then have a positive shape and a negative space. These elements will be utilized as stencils on sturdy paper, using a variety of shading and linear approaches to create gray values. The eraser is used as a mark-making tool, and the stencils act as a shield. By flipping the stencil over and rubbing with something hard (like a pencil), you can transfer the previous marks to the paper, making a reverse image, in a manner similar to the monoprint process.

The goal is primarily to fill the space and create the illusion of space, depth, design, composition, and a graphic value system.

As part of a mixed-media piece, the stencil may be glued flat. Or it may be slightly raised by gluing small layers of cut-up illustration board behind the stencil and then gluing the stencil onto the final drawing.

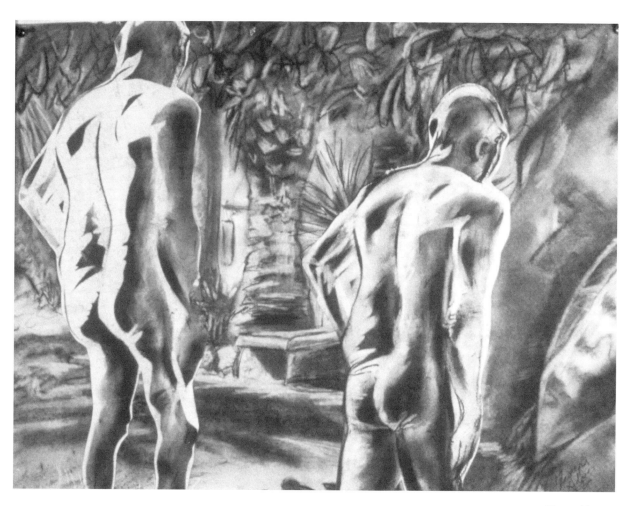

Tanya Alvarez.
Two Old Men.
Collage and charcoal. 18" x 24".

7 | Time

TIME, AS IT RELATES to drawing, may be understood in several ways. It may be about the seconds, minutes, or hours required to make the image. It also refers to the visual recording of events that occur during a particular period. And it is a factor in the effect of experience, memory, and dreams upon expressive drawing. In this last context, time may define the appearance of images more than any other factor.

Bryan Unger. Time Elapse.

Time Lapse

LEIGH ANN BEAVERS | *Minneapolis College of Art and Design, Minneapolis, Minn.*

Recording the essence of motion in a moving crowd of people.

You are asked to draw in a large public space such as a museum, student center, library, or zoo where you will to see people entering, lingering, and leaving the area. Position yourself comfortably so that you can record the human traffic throughout the location.

This exercise is begun by drawing the space lightly with a perspective that matches your particular point of view. As people enter, record their progress through the area. Forget the final product as you draw, and make your primary goal to record all the movement you observe.

Regardless of whether a human moves quickly or slowly, the main objective is to describe the essence of that movement until the person leaves the space. If someone moves quickly, then the gesture is minimal. If someone moves more slowly through the space, the form is more realized. Your eyes are constantly sweeping the space for movement and recording that action. In some situations, you have to draw an entire moving crowd of people at once. In other situations, you are able to concentrate on articulating one still form.

Depending on the amount of pressure applied by the drawing tool, an eraser might be used to draw over or through what will sometimes be an impenetrable mass of people. Some students lightly erase whole areas of movement in the midst of the drawing to make room for more images. The erased area serves as a memory of earlier activity. The final result of this investigation is a drawing that is a layered record of movement throughout a space.

24-Hour Drawing

SQUEAK CARNWATH | *University of California, Berkeley*

Learn to love your mistakes.

Some of the assignments in this book require students to draw with great speed. Squeak Carnwath's exercise falls at the other end of this spectrum. She asks her students to draw on the same sheet of paper for twenty-four hours (although the time period may be broken up over several class periods or days). Because of the length of this assignment, students will need a new ballpoint pen or fine-point permanent marker and a large sheet of good-quality paper; Carnwath says the best paper for this project has a smooth surface, either a Bristol, hot-pressed watercolor paper, or Arches.

> Draw whatever you like: a self-portrait, a school hallway, outdoor campus scenery, or a still life (as long as it will remain undisturbed for the requisite time). However, you may not erase "mistakes," nor may you start over if, say, you don't like the first five hours of drawing.

"In the beginning, students complain that their drawings will be all black," says Carnwath, "but I explain that if they don't want dark drawings, they must figure out a way to preserve the light. This is largely a self-guided exercise, although I may make a few suggestions.

"The intent of the project is to make students learn to live, even love, their mistakes or imperfections. They learn patience, and how to keep from getting bored and how to hide things they don't like. They invent ways of making marks and fall in love with their own mark-making and way of seeing. They learn about abstraction and the labor of art. In the end they are justifiably proud of their effort.

"The drawings turn out to be exquisitely beautiful, like Rembrandt etchings. Some are quite dark and moody, but others have large areas of white paper preserved. Students learn to trust their own ability and skill, and they also acquire courage. After this experience they are totally engaged in any future projects."

↓ LIBRARY
← MUSIC
↑ DRAMATIC ART
→ ART

Kirk Arneson.

Jennifer Voerman Malone.
Nocturne. *Charcoal. 24" x 18".*

Nocturne

WALTER HATKE | *Union College, Schenectady, N.Y.*

Exploring the absence of light.

Many assignments depend on the observation of light. Walter Hatke's explores the absence of light. It requires that the drawing be done at night and of the night. (Among numerous artists who have explored nocturnes, Seurat and Whistler especially stand out; others include Alex Katz, Hiroshige, and a number of the Mogul Indian and Persian miniature artists.)

The project works best when you take your materials outdoors, weather permitting, to draw as much as possible from direct observation. Through this experience you become sensitized to the atmosphere of the night, the air quality, and the nature of the light. The final image should be predominantly dark; what light there is will appear to be coming from inside the scene depicted, and there will be very few visible details. (Intricate details are, as a rule, held to a minimum.) The emphasis is on tonal masses and on conveying a profound sense of its being nighttime. Drawings may be completed indoors.

Another approach is to set up indoors in such a way that you are looking outdoors through a window or doorway. Obviously, interior references should be downplayed in favor of shapes seen in the darkness outside. As a variation, you may start your projects outdoors, concentrating on predominant shapes, such as a dramatic tree, a building, a statue, or some other figure, and then move indoors to the studio in order to develop the shapes and depth through a series of related drawings. Architectural subjects, lights in windows, street lights, clock towers, moonlight, and the like can be used to create spatial relationships and psychological drama. Wet reflective surfaces also make for further possibilities.

Daily Document

ANN PIBAL | *Bennington College, Bennington, Vt.*

Intense observation of an object or event over a ten-day period.

This is another assignment that asks students to notice some of the apparently more insignificant events in our lives.

> Ann Pibal asks her students "to observe an object, situation, or event over a period of ten days. Students may complete this assignment by creating ten drawings, or by creating one drawing that has ten layers or elements. In either case, each of the ten days is accounted for. Natural phenomena, human social behavior, the changing positions of inanimate things—all are possible subject matter.
>
> When presenting the assignment, Pibal stresses to students that their activity is a collaboration between them and the flexible world around them. And the key to a successful project is intense observation. This is true whether the student is observing a flower in a vase that wilts over time or the changing pattern of cars in a parking lot.

Student solutions have included a series of drawings done in response to a small puddle on a sidewalk, which filled with water and dried up over the course of rainy days; a recording of the exact color of the sky at a certain hour as seen from a certain vantage point over the stretch of days; a diagrammatic chronicling of a student's experience trying to save energy through the repeated turning off of the light switch in his dormitory hallway; a layered acetate drawing in which various figures were overlaid within a constant architectural space (this was done by tracing shapes from Polaroid photographs, which were taken daily); and a delicate line drawing, created entirely from a collection of tracings of stains taken from a bathroom vanity shelf (see the accompanying illustration).

*Josie Lawlor. Daily Document. 7½" x 17".
The drawing was made by tracing and
overlaying the stains left behind on a
bathroom vanity shelf over a period
of ten days.*

Brian Kleppin.

Domestic Rituals

JANICE M. PITTSLEY | *Arizona State University, Tempe, Ariz.*

Experimenting with the familiar.

Students often feel that they need to draw subjects that are in some way different, even outrageous. Janice Pittsley encourages them to find something special in even the most ordinary events.

Choose a domestic ritual, a routine daily activity that occurs in the home environment—your house, apartment, or dorm —and make that the subject of your drawing. The ritual could be one that is as common as washing dishes, or it might be a more particular experience like gathering camping materials for a trip.

Consider the entire area in which your domestic ritual occurs, not only the immediate vicinity such as a countertop. If the activity you choose is preparing coffee in the morning, you could compose your drawing so that the activity is viewed from outside the kitchen. This requires an environmental engagement with light, space, and composition. Experiment with different viewpoints and eye levels to determine the best way to compose the space you are observing. The ritual that you depict could occur in the foreground, middle ground, or background of these spaces.

Drawings that exploit changes in light tend to describe the location of the event most effectively. For example, the foreground might be well lit and the background could be dark. Or your focal area could be bright and the surrounding space in shadow. You may use direct observation of your environment or exaggerate the changes in illumination for dramatic effect.

Memory Box

Marilyn Walters | *University of Western Sydney, NSW, Australia*

The object as signifier of experiences, values, and desires.

Many assignments recognize that the way we draw things may be influenced by factors outside of the drawing and perhaps only visible in our minds. In Marilyn Walters's project, students create a series of drawings based on objects associated with personal memories.

> Students are asked to place items in a shoe box that are of significance to them as mementos. These may be trivial things such as matchbooks, empty perfume bottles, or keys. When they bring their memory boxes to class, each student introduces their "memories" to the other class members by talking about the associations and stories attached to the contents of their box.
>
> Students then begin a series of drawings based on the items in their memory box. Emphasis in the drawings is on the associations of each item rather than its form, proportions, shape, or color.
>
> From the first series of drawings, students select three for reproduction and enlarge them to double their size. Next students select two of the three drawings and draw them again, enlarging them also to double the size. In the final step the students select one drawing and draw it again at double its size. Each time, the selected items are drawn bigger and bigger and more and more detailed or abstracted. At the end of the project each student should have a series of drawings in which the significance of the objects on which the drawings are based is represented by their size and complexity.

The drawing process is enhanced by the interaction of the class members with each other and with each other's "memories." It focuses on the significance of objects in our lives as well as on the integrity of the object, and the object as signifier of experiences, values, desires.

Steve Perrin. Time Diary.

8 | *Representation / Abstraction*

ABSTRACTION HAS PLAYED a significant role in Western art for well over a century, and yet many students remain quite perplexed about how one comes to this form of expression. The assignments in this section make evident the connection between representation and abstraction. In so doing, they explain how to make the transition from one mode to the other. As representation and abstraction mutually inform each other, this understanding opens up expressive ideas for students of any persuasion.

Crystal A. Hatch. Collage Abstraction. *24" x 36"*.

All Around / All in One

Mary-Ann Kokoska | *Colorado State University, Fort Collins, Colo.*

A gigantic still life—disassembled, reconstructed, and reinvented.

Many projects emphasize the importance of personal selection and reconfiguration. Mary-Ann Kokoska's instructions do this in a very simple, direct, and effective way.

> Students are asked to set up a gigantic still life using at least forty objects from school and from home. They begin by making four or five drawings of this still life from many angles and viewpoints: up close, far away, while standing, sitting, or on the floor. The type and style of drawing should also vary, emphasizing contour, or value, or color. These initial drawings are a source of information about not only the content but also its character and surface detail. They will reflect the students' likes and dislikes through the choices they made.
>
> I then dismantle the still life and ask the students to reconstruct and reinvent it in their own unique manner. This is done through deconstructing and fracturing the original drawings by cutting them into a variety of sizes and shapes. Students then attach mismatched pieces in various ways, addressing basic principles of composition: structure, rhythm, repetition, unity. Working on the floor allows for consideration of viewpoints from all angles. Trying out many variations in compositional arrangement is encouraged before the pieces are glued in a final position. The size and shape of the collage and the level of abstraction, as well as its relation to the original still life, may vary widely.

This project can be taken a step further by drawing on top of the collaged pieces to develop a "new" composition. Even invented elements may be added by those so inspired.

From Observation to Abstraction

Brian Kreydatus | *The College of William and Mary, Williamsburg, Va.*

Investigating the formal construction of an image.

"Most students come into class being able to read only the overt content of a drawing," says Brian Kreydatus. "They don't realize that the reason we remember certain artists' images is not only because of their immediately recognizable subject matter; it's also dependent on how these artists handled that subject matter. I developed this project to bridge the gap between drawing from observation and thinking about the more abstract ideas of composition. As soon as we start to investigate an image beyond what is immediately recognizable, we are discussing its formal construction."

The objective of this assignment is to concentrate on purely formal issues in the creation of an interesting visual statement. To this end you will be required to crop a still life drawing in such a way that the immediate identification of its subject(s) becomes impossible.

Take at least three different still life objects, and use them to produce eight brief thumbnail sketches. Do not limit yourself to traditional still life materials. From these sketches, pick the most promising composition on which to base your larger and more complete final drawing in which you have cropped the original view in the thumbnail image so that we cannot recognize your factual starting point.

This problem may also be done in the reverse direction: a still life drawing is started and terminated just before the subject becomes recognizable.

Anthony Sager.

Lindsey Meyer. Line Contour.

Arbitrary Value

PAMELA MARKS | *Connecticut College, New London, Conn.*

Contour drawing as a pathway to abstraction.

This assignment is one of several that open the door between representation and abstraction. Pamela Marks says that it "gives students a more relaxed feeling about the ownership of their drawings and lots of practice in contour drawing. It also encourages creative resolutions to compositional problems and introduces a pathway to abstraction."

The class is arranged in a circle, and each student is given a small, simple object that can be described with a contour line. These objects could be sets of keys, small mechanical parts, artificial flowers, small toys, and the like. The students then begin with a quick (2–3 minutes) contour drawing of their object.

Students then leave their object behind and rotate clockwise to the next student's drawing and object, and complete another quick contour. This is repeated until the papers are filled with drawings of various scale, including some that may overlap. At this point students return to their own places and decide whether they want to add any more contours of their object to their drawings.

In the second phase, students turn their papers in all directions to look for interesting movements or directional forces and also a focal point. Then, using a limited range of four values, they work to achieve balance and integrate the background with the foreground. The values are used to describe pattern and not to create three-dimensional volumes.

Shifting Perspectives

Carol Struve | *Bemidji State University, Bemidji, Minn.*

Integrating representational and cubist perspectives.

How perspective is understood has changed greatly over the centuries. Early in the 1900s, cubist ideas about perspective challenged what by then was considered standard. Carol Struve says, "The goal of this project is to create a seamless integration between representational ('normal') perspective and cubist perspective, and to observe the different descriptive abilities of each."

Select a variety of large, medium, and small still life objects. The background and the surface on which these objects are situated should be white. Their placement should be carefully considered to create interesting visual relationships. A strong light will create dramatic value shifts and a range of shadow patterns.

Now determine how the picture plane will be divided to combine the two perspectives. What patterns unify the composition? Are there light and dark shapes that create strong visual patterns and rhythms, or do the horizontal and diagonal edges repeat in an interesting way? Begin by drawing the edges of selected forms, and extend them into space beyond the originating object.

Next draw the tops of the objects as though they were flipped up, allowing the viewer to see the top and front simultaneously. Some objects may be drawn with only two values, creating a flat geometric shape. At the same time, representational forms should be drawn as they appear, with full values and accurate scale. The composition of the final drawing should be evenly divided between both principles of perspective and also retain all the design considerations of any good drawing.

Brian Hanka. Untitled.

Mashell Black standing in front of his drawing.

Journey to Cubism

CARA TOMLINSON | *University of Wisconsin–Eau Claire*

Principles of cubism used in a life-size figure drawing.

Cara Tomlinson's assignment is among several that seek to illuminate the process of understanding what cubism is about. She does this in several stages and says, "The value for students in using these three stages is that they can slowly approach the principles of cubism through the physical understanding of a life-size project that moves from observation to imagination, all the while keeping the drawing alive and changing."

In the first stage[1] we concentrate on anatomical proportion, balance, and measurement. I introduce the importance of flexibility by requiring the students to erase, reposition, and redraw. Much of this phase is analytical.

In the second stage we concentrate on seeing the figure in terms of geometric planes. We also extend the analytical framework outside of the figure to begin structuring the surrounding space. I add new elements to the model's pose to keep the students open to change in their drawings. In this phase I stress value relationships and the intermeshing of figure and ground.

During the final stage we begin to work with the concepts of cubism, both in terms of understanding it historically and as a mode of serious play. To extend and complicate the space, a variety of mirrors, strings, and objects are added to the model setup. Students are encouraged to work with the concepts of repetition, rhythmic play with motif, fragmentation, shifting points of view, overlapping planes, and increased intermeshing of figure and ground. During this phase students base their decisions on the drawing itself and no longer refer constantly to the model.

Deriving Abstraction from Reality

Fred Wessel | *Hartford Art School, West Hartford, Conn.*

A *tool or utensil is gradually transformed in a series of drawings.*

Even though abstraction has been with us for a century, instructors continue to find it necessary to teach ways in which this aesthetic may come about. Fred Wessel has his students start by rendering a tool or kitchen utensil and its cast shadow as accurately as possible. "It is important to include as much detail as possible because this drawing will provide the source material for the remainder of the project," he says.

Put aside the tool or utensil, and use your drawing of it to create a second image, in which the original shape is distorted. Imagine it being fractured, inflated, stretched, and so on, and at the same time enlarge it so that it now intersects the edges of the paper, creating new, trapped or negative spaces.

Now use image #2 as source material for a third drawing, in which you identify interesting shapes and patterns and misshape them. Insignificant shapes may become dominant, exciting shapes may be repeated, and negative areas can be filled with patterns derived from the drawing process.

Repeat the previous step, using drawing #3 to make a fourth one, in which you continue moving away from reality toward abstraction.

Take the most exciting of the four drawings, and use it as a study for a larger drawing. You may grid it and the larger paper for accurate enlargement, or just use it loosely as a point of departure. In this last drawing you should be drawing for the formal qualities only.

Nicholas Rice.

9 | *Anthropomorphism*

MOST STUDENTS ARE intensely interested in who they are, and by extension, in things they see as belonging to them. This group of problems explores ways in which this desire to imprint oneself on objects may lead to creative interpretations of them in a drawing. A by-product of this experience is that it leads to a better understanding of why certain drawings by great masters look the way they do.

Kristin Dobberstein.

Draw It Like You Mean It

KAREN BAUER | *Webster University, St. Louis, Mo.*

Four approaches to a compelling perception of a still life.

This assignment belongs among those in the book that are concerned with imbuing objects with a particular individuality. Karen Bauer says, "The focus of this exercise is to adjust the form as clearly as possible to reflect a personal perception of a still life. The underlying intent is how to discover and convey why a subject is visually exciting."

Several small still lifes or "events" are set up on a table,[1] each containing about three objects of varying shape, texture, size, and so forth. A strong light should be focused on these subjects to create a wide range of values.

Bauer has her students prepare a sheet of paper with four windows, each of which will contain thumbnail sketches about 6" × 8". They are then asked to walk around the still lifes to see that each view carries a different message and no particular view is more or less correct. After their first drawing, students consider whether the composition they just finished reflects their initial reaction to the subject. For the second drawing, they are urged to get closer to what they want to say about what they are seeing. Bauer asks that they "exaggerate the relationships, set up the big gestural movement, divide the page with conviction. The third drawing should establish light and dark divisions, and be created with marks that are sympathetic to the qualities of the subjects. The fourth drawing should bring together the formal considerations as well as demonstrate empathy for the subject. It should communicate what the viewer found compelling."

Psychological Space

SCOTT BETZ | *Weber State University, Ogden, Utah*

Imparting emotion without a figure.

How do we create emotion or feeling in a drawing? Whereas illustrators frequently use a human figure for expressive purposes, Scott Betz is interested in how this can be done without a figure. He finds suggestions for ways to impart emotion in other art forms. "For example, how does the stage designer create a feeling of openness or, conversely, claustrophobia? In movies, how does the lighting affect the scene? Why aren't horror films lit like a department store? How does the camera angle lead your emotions by making you feel small or large, looking up with respect or fear, and looking down in pity, disgust, or superiority?"

The challenge in this assignment is to see how convincingly you can suggest strong feelings or sentiments, not by using a figure, but through the simple manipulation of three visual devices: space, light, and perspective.

Betz offers a list of possibilities in each of the categories.

SPACE	LIGHT	PERSPECTIVE
a bedroom	using a single bare bulb	looking upward
an elevator	using a candle	looking downward
inside a box	dawn or dusk	up or down stairs
on the roof	using a car headlights	at an angle
inside a cellar	using moonlight	looking across

The goal at this point is to decide what kind of emotional content you wish to pursue. Experiment for a while with these and your own ideas, mixing the possibilities. The space, light, and perspective in the drawing must be developed so that the emotion becomes fully evident. Its characteristics must be pushed increasingly to remove as much ambiguity as possible in the psychological effect of the work.

130

Ramiro Oseguera.
Psychological Space.

Thomas McCabe. 35" x 23".

Plant Gesture

Joseph Byrne | *Trinity College, Hartford, Conn.*

Draw what the plants are doing, not what they look like.

In Joseph Byrne's classes he gives this exercise both to introduce the concept of gesture and to draw attention to the importance of marks in visual language. It also points out a characteristic not normally associated with plants.

A number of large plants are set out on the floor in the center of the studio. They are selected for their distinctly different structural and physical characteristics. Students are asked to think about how a plant grows and try to understand this through careful observation and verbal description. Does the plant shoot up with a vertical dynamic almost seeming to deny gravity? Does it grow out laterally—perhaps expanding in gently curving arcs from a central core? Is the plant made up of curving stems pulled down at the ends by large, drooping leaves? Or does it have small, delicate leaves that seem to hover around a less obvious stem structure?

Students begin by mimicking the directions and dynamics of the plant gestures using their hands and arms. They are then asked to draw what the plants are *doing*, rather than what they look like. They have to choose a linear mark—straight, curved, short, long, thin, thick, slow, heavy, light, delicate, bold, fluid, or cramped—and then construct their drawing through the repetitious accumulation of these marks.

How these different marks relate to the dynamic characteristics of the plant being studied is what matters most. The effectiveness of the marks is also influenced by the students' choice of tools and medium. Discussion reveals how all these choices have a profound impact on the student's success at effectively suggesting the gesture of a plant.

The Life and Times of an Object

ALLYSON COMSTOCK | *Auburn University, Auburn, Ala.*

Storytelling about the mundane things in our lives.

Many people who collect old items wonder about where they've been in the past. Allyson Comstock's assignment is a form of storytelling about the mundane items that are part of all our lives.

> Select a common object, yet one that is interesting enough to hold your attention for several drawings. Possibilities might be a light bulb, a baseball cap, a plastic flower, needle nose pliers, or a roll of tape. Some of these, like the light bulb, are static; others, such as the pliers, may be opened and closed. It is also helpful for the object to be small enough so that it may be easily held in the hand and be readily placed and observed in different environments.

Christina Brooks.

Each object will be the lead actor in a series of images on long, thin paper (such as cash register receipt paper) that will appear as one continuous drawing. The selected object will "perform" in the following scenarios, but not necessarily in the same sequence:

- From below
- In a night scene
- Flattened
- Torn or broken
- Blurred
- Repeated in one space
- Distorted
- With realistic color
- With subjective color
- Folded
- From above
- Invisible
- As a reflection

Detail.

The final length of each drawing will be determined by the student, but the same object must appear in each frame. Comstock asks that the drawings be worked on in at least six different media.

Mystery of the Wrapped Object

Brigham Dimick | *Southern Illinois University, Edwardsville, Ill.*

Revealing the planar structure in the folds of drapery.

Many assignments seek to address traditional issues in drawing in a way that brings a new interest to them. Brigham Dimick does just this. He says that his project is designed to increase students' sensitivity to planar analysis of drapery.[2] "Because they learn more if they are truly interested in what they are doing, I often link formal development to an expressive goal. In this case, the student is asked to think about using drapery to create mystery."[3] He continues:

> I ask students to find a form that intrigues them both for its visual qualities and perhaps because of their personal relationship to it. They are told to experiment with various ways of wrapping it with a material, aiming to obscure its identity enough to create a sense of mystery. At the same time, they should expose enough of the underlying form so that a sensitive viewer could, through consideration, discover the subject. It is important to think about draping the subject in terms of tight and loose folds, exposure and concealment, tying, cinching, collecting fabric, and so on. Different ways of lighting the subject will both assure that it is visually interesting and reveal the planar structure in the folds of the drapery.
>
> By eliminating lines from the drawing (think of Seurat's Conté drawings), students will create space by concentrating on the edges of planes and their respective tonal contrasts. The edges of their forms should be such that, as the form advances, they get clearer and sharper with more individual distinctions.

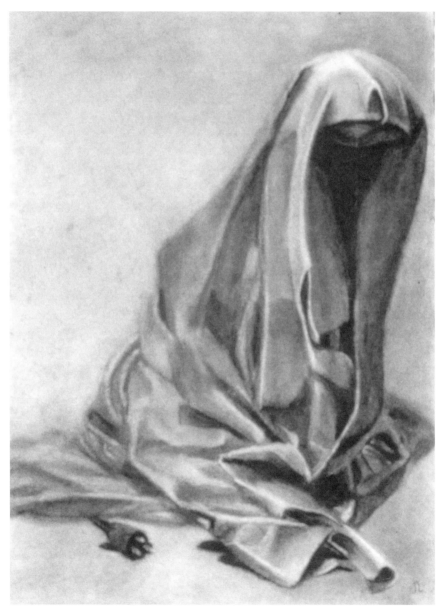

Joshua Laughlin.

10 | *Art from Other Arts*

STUDENTS ARE FREQUENTLY at a loss for ideas or what they think of as inspiration. They are unaware that this sought-after commodity may be found among other experiences in their lives. These assignments suggest that film, music, the local museum, or a book they've read could provide the context for original work. This awareness has the felicitous effect of connecting drawing to a much wider range of human creativity.

Chris Cunningham. Geyser. Charcoal. 24" x 18".

Drawing from Films

EVE ASCHHEIM | *Princeton University, Princeton, N.J.*

The challenge of capturing cinematic time and motion.

Eve Aschheim asks her students to draw from a film, a seemingly impossible request. But as her students try to show motion and account for various filmic issues such as time,[1] they learn to draw freely and with great speed. She says that her exercise does not always result in "good" drawings but often yields interesting ones: "Students will take a leap into the void."

The incorporation of time becomes one of the most problematic requirements of this exercise. If a film showed a bird flying in real time, a student might follow its flight by drawing separate "snapshots" of the bird as it moves through space. Or the student might attempt to simulate the gesture of a particular kind of motion, or diagram the concept of motion. Then again, the student may attempt to represent filmic time, the time created by camera work and editing techniques; the wipe, jump-cut, fade, close-up, zoom, pan, dolly, freeze-frame, hard and soft focus, slow and fast motion, and so on. Attempts to capture filmic time might include dividing the page into sections, blurring or superimposing images, and making abrupt scale transitions.

A film she used is called *From London to Brighton in Ten Minutes*.[2] A time-lapse camera was mounted on the front of a train, thus condensing the normally one-hour trip to a mere ten minutes. What made this film especially suitable, she says, is that it "has certain constants; the tracks, although changing in shape and direction, are approximately in the middle of the screen, the horizon is persistent if fluctuating, and the distant landscape remains in focus until it whooshes by in a blur."[3]

"Film presents phenomena often impossible to observe in real life," says Aschheim. "It allows for control of the stimulus, a framed image, the presentation of many kinds of time, subjects, and physical points of view (camera angles); and it may be played repeatedly. It would be difficult to take a class to see a real geyser!"

Musical Scroll Project

LAURA BATTLE | *Bard College, Annandale-on-Hudson, N.Y.*

Drawing the sound of music on a ten-foot scroll.

A number of artists have been interested in the relationship between sound and sight.[4] Laura Battle asks her students to select a piece of music, preferably one without lyrics, and then devise their own musical notation system, which will describe the evolution of the piece on a 10' × 1' scroll.

> The project begins with listening to single sounds (such as tuba, drum, and saxophone) and doing quick drawings for each.[5] Then students establish a "cast of characters" for their piece and do working drawings before committing to the large scroll. The selection of drawing media will depend on the nature of the sounds and therefore will be mixed.

Initially students are asked to isolate the major sounds and to assign forms to them, in a sort of visual onomatopoeia. Isolated instruments, sequences of notes, and/or recurring chords should be indicated by colors, shapes, gestures, textures. Some kind of notation may be needed to indicate different octaves, the duration of sound, and the occurrence of rests.

Emphasis is placed on working nonobjectively in order to reinforce the power of color, material, and shape to convey the sensation of the sounds, rather than allowing image, narrative, or literal associations to take over. The use of the horizontal format is in order for students to experience the drawing and the listening as evolving over time.[6]

Emily Bowers.
China Girl (David Bowie).
Mixed media.

Katharina Dish. Cellos.

In the Garden

ANIA GOLA-KUMOR | *Rocky Mountain College of Art and Design, Denver, Colo.*

Make multiple drawings of a single subject to discover different interpretations.

Ania Gola-Kumor derived this assignment from looking at Jennifer Bartlett's *In the Garden*.[7] She says, "Bartlett's book is about making a series of almost two hundred works on paper devoted to a single theme: the garden of the villa she occupied in the south of France. It is a study of one subject resulting in two hundred different solutions, each one fresh and different. Some of them are representational, some abstract. They range from elaborate drawings to fast sketches, always depicting the same swimming pool, five cypress trees, and a statue of a boy. Sometimes Bartlett looks at the pool at eye level; at other times she appears to see it from high up. Each drawing is an attempt to show this scene from another angle. In her hands the view becomes a source of inspiration for an enormous body of work." What is also significant about this series is that Bartlett's first assessment of the scene was that it was boring. Her series testifies to the power of seeing to reveal and make interesting.

> Make a minimum of twelve small drawings from a single subject of your choice, executed with a variety of tools and wet and/or dry media. Study the same subject to discover different interpretations. While working on the same subject over and over again, it is possible to arrive at a point where new solutions appear almost effortlessly. The repetition itself offers a way of arriving at stronger interpretations or departing entirely from representation.

Drawn from the Collection

HOLLY HUGHES | *Rhode Island School of Design, Providence, R.I.*

Inspiration from a museum object.

Holly Hughes's project depends on a visit to the college, university, or municipal museum.

Take a long stroll examining all collections except those of European and American painting. Find a group of objects and images that interest you. After spending some time sketching these to familiarize yourself with them, select one. Decorative and applied-arts displays like those of ceramics, furniture, metalwork, or textiles offer exceptionally inventive and interesting visual experiences. Or you may engage in an investigation of exhibits of Japanese prints, Hindu or Buddhist sculpture, Egyptian sarcophagi, or low-relief sculptural friezes. You will not only gain deepened respect for the beautifully achieved and highly developed visual languages these works employ, but also expand your interest in learning more about the cultures that made them and the uses to which they put them. Imagine yourself entering into a dialogue or conversation with the work you have chosen.

Examine your selection through drawing its iconography and look at the formal attributes. Think carefully about the qualities of touch, line, space, rhythm, material, color, degree of abstraction and/or representation, and so on, and decide what aspects appeal to you most. What attributes would best invite experimentation? Your goal is to crack open and expand your visual vocabulary while at the same time challenging and extending your hands-on skill. Inspired by and developed from the study of this specific object, create a visual language and explore its use in a suite of works on paper.

146

Laura Snyder.
Inspired by a stone
Vishnu from India.

C.B.

Art to Music to Art

NANCY MANTER | *Princeton University, Princeton, N.J.*

Drawings based on a Philip Glass composition inspired by photographs.

One art often engenders another. We are all, for instance, familiar with films derived from books. Nancy Manter's project is based on the musical composition entitled *The Photographer* by Philip Glass, who wrote it in response to the motion studies by the nineteenth-century photographer Eadweard Muybridge. Most students are familiar with Glass's work, although it is not a prerequisite, nor do they have to have formally studied music or played a musical instrument.

> On listening to the composition, students are asked to take out their notebooks and make notations and sketches as they try to visualize images and structures inspired by this music. They should realize that the music has a structure that holds it together. It comes to an end at several points and begins again with a different set of instruments, in another scale or with changed tonalities. The essence of the original score, the structure, continues and eventually "reconfigures" back, beginning the whole pattern again. These are important concepts to listen for and can be readily translated into a visual format.
>
> The sketches are then used to create large-scale drawings in which students transcribe their own interpretations of form and value based on Glass's piece. These drawings should develop over time, laying down the forms at different intervals as Glass does in his music.

Manter suggests that students later select another musical piece by any composer of their choice. Working again from sketches to large-format drawings, they then hang these new drawings next to the Glass drawings for a critique.

Visual "Blues"

René J. Marquez | *University of Delaware, Newark, Del.*

A *video on Lightnin' Hopkins translated into the language of drawing.*

Among the assignments that take off from another art form, René Marquez's is perhaps the most complex in that it requires a visual translation not only of a video but also music and words.

Create a personal visual representation of the blues musical genre based on your experience of the videos *The Sun's Gonna Shine* and *The Blues Accordin' to Lightnin' Hopkins*.[8] Consider that you are translating one language (music) into another (drawing). What aspects of the original musical form will you consider in creating your visual rendition of it?

Reflect on the fact that, in the video, three main layers intertwine with each other: visual images, sounds of music, and text (both spoken and sung). The three layers are divided further to include textures, rhythms, intensities, and so forth. By mixing media, you should strive for the same effect of layering, using a visual vocabulary that also includes textures, rhythms, and so on.

The richness of your visual vocabulary will allow for depth and subtlety in what you have to say. Avoid creating an image or images that are simply literal or a one-liner. That is, give your viewers something to think about, to contemplate at length, and something to take away with them in the form of continuing thoughts or questions. Do not simply illustrate an image that you feel represents the blues. Make a statement that requires reflection and demands a response from your viewer.[9]

Examine your own assumptions and push yourself to think outside the box.

Alexandrea Clark.

Come In 6/10 Elaine M. Verber

Elaine Verber. Come In (Living with the Paine).

Home Is Where the Art Is

GAIL PANSKE | *University of Wisconsin–Oshkosh*

Using drawing to bring a masterpiece home.

Many art departments and schools are near a museum, but often students are reluctant to explore these institutions, which have not been part of their experience. Gail Panske has devised a delightful way of getting her students to the museum so that they can "acquire" a work of art.

> This assignment makes students relate to objects in a museum in a very different way than usual. They are asked to visit a local art museum[10] (ours is the Paine Art Center) and pick out five things to sketch. These may be paintings, sculpture, furniture, architectural elements, or perhaps other items owned by the institution. (For instance, if it's the Metropolitan, they might choose armor.)
>
> Use a sketchbook and pencil. (Museum personnel do not like messy media.) On site make a minimum of two sketches per object for a total of at least ten sketches altogether. When possible, do multiple thumbnail sketches of the subjects from different points of view. Also remember to record their relation to the environment: for example, the wall, the floor, and the lighting.
>
> When the drawings are completed, take them home. Imagine that you have one of these objects where you live, and make two final drawings including the information from the ten sketches. For example, "hang" the William Merritt Chase painting from the library of the Paine in your room. What would some of the furniture from one of the period rooms look like in your living space? Consider carefully the context in which you put your piece from the museum. What kind of light does your room have, and how does the scale of the object relate to the space of your own surroundings?

Invisible Cities

Kevin Wixted | *School of Art and Design, Alfred University, Alfred, N.Y.*

The fantastic cities described in a novel become source material.

In this assignment, a book is the point of departure for a drawing. Kevin Wixted asks his students to read the Italo Calvino novel *Invisible Cities*.[11] He says, "This book takes the form of an elaborate conversation in which explorer Marco Polo describes his visits to fantastic cities under the domain of ruler Kubla Khan. As Marco Polo builds image after image of exotic places, the novel begins to seem a testament to the modernist idea of the inexhaustibility of formal invention. Each short chapter brings a new city palpably to life, conjuring many strong, if fleeting, images."

This assignment addresses both the potential and the difficulties of using literature as source material for visual art. First the class discusses the form of the book and its relationship to possible metaphoric meanings. Correlations are drawn between artist as explorer and artist as storyteller. Ideas about translating a work of literature into visual art without being illustrative are addressed.

Students are then asked to produce an extended series of drawings based on their interpretation of particular cities. The size and scale of the work as well as the materials and techniques used in depicting each city are considered in relation to themes and moods developed in the text. Working in series allows students to respond to both the Calvino story and their own artwork. As the series progresses, the formal dialogue between drawings becomes a dominant concern, making the work less about Italo Calvino and more about the person creating the drawings.

Elizabeth Treichler.
24" x 18".

11 | *Photographs*

*M*OST STUDENTS HAVE SEEN an infinitely greater number of photographs than drawings. Therefore it is not surprising to find them resorting to photographs for drawing ideas. But, as we all know too well, they tend to equate the simple copying of a photograph with the making of an original drawing. The authors who contributed to this section realize the power of photographs and have developed inventive ways of working with them that use photos as the starting point of and the ingredients for drawings that in the end have a life of their own, quite independent of the sources.

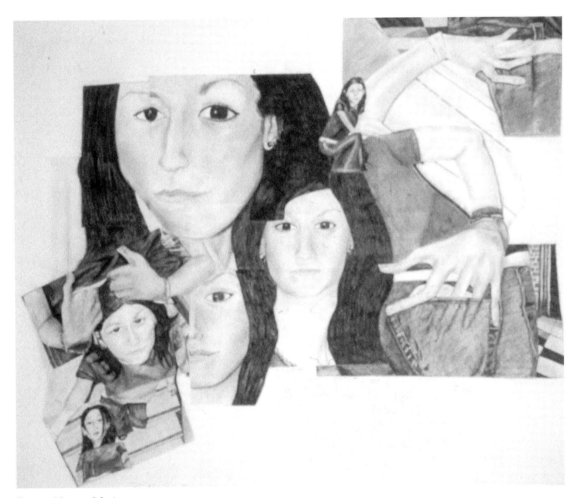

Doreen Nocera. Marisa.

Animated by a Photo Collage

Mia Brownell | *Southern Connecticut State University, New Haven, Conn.*

A collage of your own photos of a single object becomes a guide for composing your drawing.

Since photography has been with us for over a hundred and fifty years, it's surprising that there are still people who feel that it has no place in the making of art. Mia Brownell offers an assignment that uses photography as a tool for seeing and a means to a nonphotographic end. This assignment is helpful for students who have never worked subjectively before, and it can ease them into an understanding of nonrepresentational imagery.

Brownell asks her students to photograph a single object from multiple perspectives, using one or two rolls of black and white film. The selected subject might be anything familiar, but she feels that some of the most creative results have come photographing the figure. In the course of taking pictures, it is important to vary the scale and perspective as much as possible. After the photographs have been developed, she asks the class to create a collage, cutting and pasting their images into interesting compositions: "The collage will be a guide for composing your drawing. Be playful with the distortions the collage will create of the subject."

The next step is to translate the collage into a drawing but not to copy it directly. The drawing should extend the random distortions and compositional dynamics of the collage. Eventually the collage should be put aside so that the drawing may begin to come alive on its own. "Translating the photo collage into a drawing introduces the student to the possibilities of creating an image of a single subject with multiple perspectives and fractured spaces that challenge traditional ideas of perception," Brownell observes.

Expanding the Narrative

David Schirm | *State University of New York at Buffalo*

Expanding upon a story suggested by a photograph.

Many good photographs tell a story. David Schirm's assignment explores how that account may be altered to become something quite different but still valid. He says, "This assignment is useful for introducing students to narrative art and seems to work especially well for illustration students."

Students are asked to pick a photograph from a collection that I bring in of images by well-known photographers. I deliberately pick evocative imagery, sometimes from Pulitzer Prize–winning photographs or from photographs that have an ability to escape or expand upon their original context. I then photocopy the selected pictures a few times so that the detail is somewhat obscured and the context is partially dissolved, in order to emphasize the emotional content of the photograph.

Students are not given any text accompanying the photographs, so that they are left in the dark about the specifics of what they have seen and what they are interpreting. The first step is to use the "photograph" as a reference point to mark the beginning, middle, or end of a story. After that selection, the student is asked to expand upon, obscure, or redirect the narrative. The object is to create two panels that complete a three-part narrative sequence. The drawings may be of the middle and end, or the beginning and middle of the account. The entire process is open to individual interpretation that can engage straightforward illustration or varying degrees of abstraction, depending upon the student and faculty supervision.

Colin Hargraves.

Melissa Ball.

Constructing the Grid /
The Grid as Structure

BARBARA SIEGEL | *Parsons School of Design, New York, N.Y.*

A drawing collage with photocopy fragments.

While this is another assignment derived from contemporary interest in the grid, Barbara Siegel uses this organizing device to quite different ends.

> Choose three black and white photographs by a recognized photographer such as Bill Brandt, Walker Evans, Berenice Abbot, M. Álvarez Bravo, Dorothea Lange, André Kertész, Diane Arbus, Roy de Carava, Lee Friedlander, Paul Strand, Robert Frank, Edward Weston, Henri Cartier-Bresson, or Jacques-Henri Lartigue.
>
> Make several photocopies of each photograph (enlarging any that are smaller than 6" × 6"). Divide and cut these into 3" × 3" squares. On an 18" × 24" sheet of paper, recombine a selection of the photocopied squares with about an equal number of your own 3" × 3" drawings to create either an 18" × 24" or an 18" × 18" drawing collage. The drawings in the 3" × 3" format should be a response to the image of the chosen photocopy fragments. Carefully observe the compositional structure, value relationships, and texture of the photo fragments. The drawing may be linear or tonal. (Pencil, charcoal, ink, or marker may be used.) The grid should be structured to establish varied but coherent rhythms of value and form across the picture plane. The same image may be repeated more than once. Many possible arrangements of the squares should be tried out before gluing the final composition. The squares may be contiguous, or a uniform interval may be left between each one. At least one-third of the grid units must be drawings.

Drawing from Microscopic Images

Robert Straight | *University of Delaware, Newark, Del.*

Projections of microscopic slides produce abstract imagery.

Several assignments address the issue of the relationship between representational and nonobjective imagery. Robert Straight's project helps students understand that "representational art is not always simply the world as we normally see it. In addition to challenging and expanding the concept of representation, this assignment also forces students to work creatively and think about drawings that expand and change over a period of time. The drawings produced with this project appear to be nonobjective but are in fact representational. Students come to understand that abstraction may have an intellectual basis in the real world."

To prepare for this class, the instructor needs to obtain a range of microscopic slides that show the structures of organic materials such as dust mites, muscle tissue, blood, protozoa, and plant tissue. Inorganic materials such as computer chips also work well. Typically five slides are used for each drawing.

After reminding students that they will be basing their drawings on several slides and should therefore anticipate compositional possibilities and negative spaces, the instructor projects several slides (perhaps five) for a specific period of time.[1] Students respond to the visual information on each slide. After all the slides have been shown, additional time is provided to allow students to tie areas of their drawings together and add or subtract elements from their compositions.

Because the slides are never previewed before the exercise, this project usually takes at least one try for the class to understand the possibilities of the visual material.

164

Lauren Placko. 22½ʺ x 30½ʺ.

Photograph by Travis Stiles. Chrome Panel #1.

Drawing by Larry A. Troester III. Out of Focus.

Slides Out of Focus

PETER THOMPSON | *Coe College, Cedar Rapids, Iowa*

Fuzzy focus removes the distraction of detail.

Normally we try to focus slides, but Peter Thompson has found that poorly focused ones serve well for his assignment:

> This exercise requires a projector and a slide chosen by the instructor that will produce a good tonal range and an interesting composition. Black and white photographs work well. The slide is projected out of focus, and the students, not knowing what the image is, begin to draw. The goal is to consider relationships of shape and value when the distraction of detail has been removed. The drawings should be as soft-edged and indistinct as the projected image. This quality may take some time to develop. Hands, erasers, paper towels, and soft drawing media may be used to blur the image and adjust the value relationships.
>
> During the initial phase, the drawings will remain entirely nonobjective. After the drawings are well developed in their fuzziest state, the slide is focused more to provide additional information. Students proceed to revise and refine their drawings based on this new information. The process is repeated several times. Often students become so attuned to relationships of shape and value that they fail to recognize the subject of the image even as it approaches its fully focused state. Going past the point of recognition, adding detail, and making the drawing more realistic is unnecessary and probably counterproductive.

Pinhole Camera Project

Lance Winn | *Carnegie Mellon University, Pittsburgh, Pa.*

A historical technique yields unexpected images.

We are accustomed to thinking of the camera as a device that accurately records what we have seen. Yet most of us also know that photography imposes its own reality. This idea forms the basis for Lance Winn's assignment using a pinhole camera.[2]

The pinhole camera, says Winn, "gives students a physical approximation of how the human eye functions and makes clear to them the complexity involved in the act of vision." In doing this project they are also helped to understand the movement of a message through the eyes, mind, and hands (or other parts of the body). One positive outcome of the pinhole photography process is that the technology limits actual control; so, no matter what the subject, the camera will interpret it in an unexpected way. Some of the most interesting drawings come out of the incomprehensible abstractions resulting from any movement that occurs during the five minutes while the lens is open. Finally, students must understand how to interpret value, as they are forced to work from negative to positive in their drawings.

First, students are asked to make a quick value translation of their photographs. Later this serves as a reference for large-scale drawings. For their final drawing they are asked to translate a small negative image into a large-scale positive drawing. Because the negative image makes it difficult to even put a name to some of the subject matter, students are able to develop a certain distance from their subject. Distortion and abstraction are built into the process, and many students are surprised to see that the final results of such a directed process may result in such varied outcomes.

Amber Cunningham.

12 | *Unusual Subjects*

*A*s is by now apparent, a large part of this book is devoted to novel interpretations of classic drawing issues. But some instructors find that confronting students with unusual drawing matter may bring about unexpected (and positive) outcomes. These subjects tend to be connected in some way to the lives of the contributors and thus suggest that other instructors might consider some material from their own experience to bring new and useful ideas into the classroom.

Wese Hawthorne.

Small Animals

PATRICIA LAMBERT | *Parsons School of Design, New York, N.Y.*

Drawing models whose movements are totally unpredictable.

Traditionally, gesture drawings have been made from models who switch poses at anticipated intervals of so many seconds or minutes. Patricia Lambert's assignment uses very different models whose movements are totally unpredictable, as is the frequency with which they change.

She has used many small animal models and finds that their individual habits suit them to different approaches: "Gerbils, mice, hamsters, and ferrets are very active. Guinea pigs and rabbits tend to sit. Cats are especially good at being still when stalking,[1] and kittens provide great comic relief. Small animals are rarely in repose and play most of the time unless napping or eating. An open habitat such as a large glass terrarium, or large wire cages with saw dust, may be helpful for watching these lively happenings."

Lambert adds, "Many seventeenth-century Dutch still life painters included small animals in their arrangements. Jacques de Gheyn also drew small animals for scientists looking for accurate illustrations to accompany their work. His delightfully expressive renderings of these small subjects are singular in the history of art."

The student is asked for two different approaches to the animal model. The first drawings should be made as quickly as possible, not for accuracy of detail, but for the excitement and expressiveness of the gesture. Then, when the animal is still, the contours of the shape of the head, ears, and body may be explored, and value changes added as appropriate. Students are encouraged to move around freely and change sight lines and angles.

Sometimes it is fun to use a digital camera at high speed to catch the subject yawning, licking, cleaning its face, and so on. The stopped action can be put into an Illustrator or Photoshop file and worked on at a later date as an overlapping contour drawing. The spaces in the patterns of these overlaps may be designed with color or value to create a digital drawing.

Prom Dresses

Jane Lund | *Smith College, Northampton, Mass.*

Vintage gowns or costumes become an exercise in exploring identity as well as drawing skills.

While this problem is not ostensibly about student identity, in actual fact it turns out to be so. The subject of Jane Lund's assignment comes out of the prom experiences of what would now be the mothers and grandmothers of current students. She says:

> I provide 1950s-style prom dresses for this exercise, although any kind of unusual clothing would suffice (such as fanciful costumes obtained from theater departments). These dresses, with their intricate and eccentric styling, are excellent subjects for drawing. I usually place them against freestanding neutral-colored backgrounds, although in one instance a black cloth draped over a freestanding chalkboard worked equally well as a backdrop. Each dress is lit by a single source of light, creating dramatic shadows on the fabric and the background.[2]
>
> Students begin with a piece of paper that is longer than they are tall. The paper is taped to the wall or tacked on with pushpins. The students have to work standing up, and as the dresses are behind them, they have to turn to look at the subject matter. This situation requires reliance on visual memory and demands study of each detail before turning back to the drawing

This exercise enables students to work in a large format, combines detail with gestural drawing, and improves visual memory. One intriguing observation has been that almost every dress that was drawn looked as though it would fit the student who drew it.

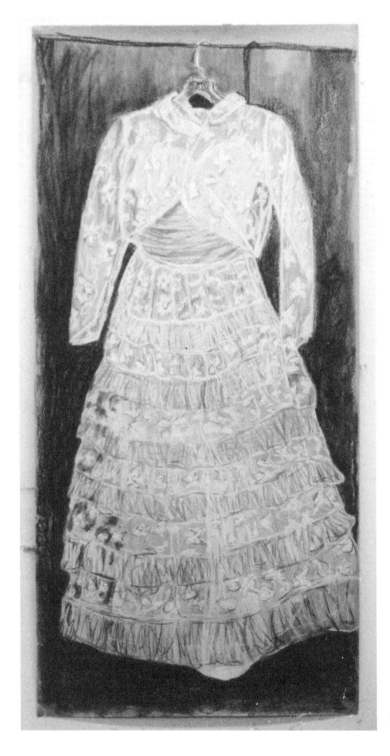

Emily Kolod.
White Prom Dress.

Scott Duquette. Dry Dock.

Mystery and Ambiguity

WILLIAM P. REIMANN | *Harvard University, Cambridge, Mass.*

Thoughtful handling of stairs may evoke an obscure and unsettling situation.

Mystery is something that students love and yet continually fail at conveying visually because of the many clichés routinely associated with this scary idea. William Reimann has found a theme that produces the desired effect and avoids the common pitfalls. He says, "The cinematic potential for mystery that stairs provide has been evident ever since the 1925 film *The Battleship Potemkin* and later was exploited repeatedly in Alfred Hitchcock's movies, such as *Psycho* and *The Thirty-nine Steps*. Writers have also understood the way stairs could be used for enigmatic effect. The classic tale *The Hunchback of Notre Dame* by Victor Hugo and the contemporary thriller *The Silence of the Lambs* by Thomas Harris are obvious cases in point.

Find some stairs that are actually, or potentially, ambiguous in their meaning. Make a drawing of them that will invoke, reveal, or conjure up for your viewer a sense of their potential for uncertain comprehension. Some of the more obvious selections might be stairs going to a dark cellar (from inside the house or from an outside bulkhead) or stairs leading to an attic. Other locations to consider are fire escapes, tank stairs, smokestack stairs, ships' gangways, or the grand hall of a mansion, museum, or train station.

Merely reporting on how and where these stairs are to be found isn't going to do it. Something about your choice of viewpoint, your organization of the page, your control of light (and dark), will give you the means to control and interpret what you see. All of these considerations working together should play a role in evoking the specifically desired response of being faced with an obscure and unsettling situation.

Rachel Kruse. An Eye for an Eye.

Front Page

Max White | University of Wisconsin–Whitewater

Deriving an emotional and aesthetic response from a news story.

Max White asks her students to each pick out a headline story from the newspaper that has the power to elicit a strong emotional and visual response. She asks them to consider how they are personally affected by the story. "Is the political personal? What images does the story conjure up in your mind's eye?"

> Students should select their story from the front page of a national paper like the *New York Times* or the *San Francisco Chronicle*. Their local hometown newspaper might also serve, but not the fabricated headlines of a tabloid like the *National Enquirer*.
>
> Although some stories may be accompanied by a photograph, students are expected to build a visual interpretation all their own. They should remember that they are not doing a narration or illustration of the article; rather, they should consider the source as the core from which to draw an emotional and aesthetic response.
>
> In doing this, they are limited to using a monochromatic palette (white, black, grays, and a chosen hue). This restricted palette forces them to be creative and stretch their interpretative powers. Some works by well-known artists that may help students to better understand the project are Goya's *The Sleep of Reason Produces Monsters*, Sue Coe's *How to Commit Suicide in South Africa*, and George Tooker's *Government Bureau*. Students will begin to understand that the imposition of limited resources can actually strengthen the impact of an image. In fact, the effectiveness of this project may gain if the gap between the colorful newspaper account and the understated, muted tones of the student response is very great.

13 | *Word-Based Exercises*

ALTHOUGH THE RELATIONSHIP is not as close as that between between words and music, words and art have had a certain affinity for quite some time. In recent years, words have sometimes become an integral part of art, and so it seems appropriate to include a few assignments that either depart from or include words in the final image. What is particularly interesting in this group is the great variety of ways words may be used to generate and/or complete a predominantly visual statement.

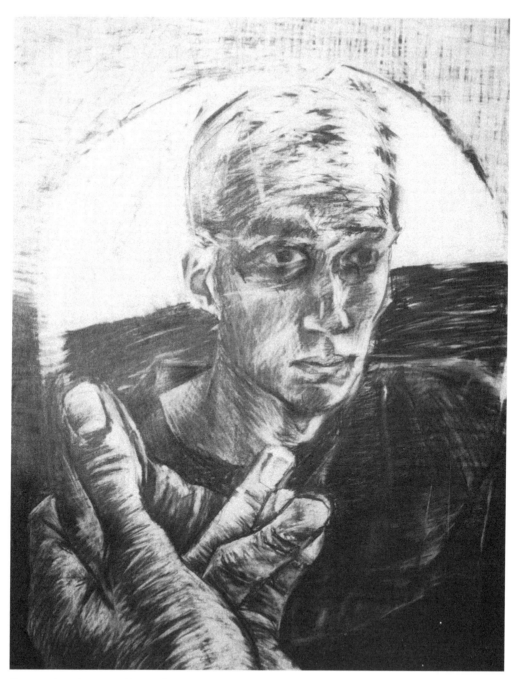

Drawing by A.B.N. Graphite. 24"x 18".

Heroic Drawing

ELEN A. FEINBERG | *University of New Mexico, Albuquerque, N.M.*

Make visual your idea of the "heroic."

Many contemporary artists use words as source material and often include them in their work. Elen Feinberg's assignment is derived from a particular word category: adjectives. While many other choices might serve,[1] Feinberg likes the word *heroic*, and her problem investigates how each individual conceives of this idea and how their varying views can be made visual.

Feinberg suggests using basic dictionary and encyclopedia definitions to begin. Then she asks her students to make a list of what and/or whom they consider to be heroic. Examples of subjects that may be explored include architecture, sculpture, or other artistic works; specific individuals; music; writings (novels, plays, poetry, essays); film; and dance.

Based on information that has been selected from these varied subjects (as well as from the dictionary and the encyclopedia), students are asked to develop a group of sketches that make visually heroic one or more of these concepts. Feinberg asks: Are there overlaps? For example, are there qualities in individuals whom you consider to be heroic that share those of architecture or writing? Which materials, formal considerations, and imagery would be most visually effective in expressing the characteristics of the heroic?

She tells her students to look for the constants and begin to correlate a variety of considerations, including materials, scale (can the heroic be Lilliputian?), form, edge, value, texture, and color. "Experiment with physical depth," she says. "Perhaps your drawing will need to come off the wall into the viewer's space. Or, alternatively, the heroic may be expressed in an utterly two-dimensional manner."[2]

After students have chosen which idea(s) would be most effective as a springboard to express the heroic, the next step is for each student to select the appropriate materials and imagery: figurative, imaginative, abstract, geometric, minimal, transfer, digital, or a mixture of these. Then, using their notes, students create a series of three final drawings that make visual their idea of the heroic.

The Shape of Fear

BETH GEMPERLEIN | *State University of New York at Buffalo*

Guns, cancer, snakes, and other words that evoke scary images.

Students have always had a predilection for scary stuff. Beth Gemperlein takes this interest and uses it to move their thinking into abstract realms that still carry the original emotion.

This project aims to explore abstraction and metaphor through large drawings based on subjects that students fear. First we discuss how to abstract images by re-thinking them through reshaping, distorting, cutting, reassembling, and morph-ing, and then how to see them metaphorically. Next students need to make a list of things they fear, both physically and emotionally.[3]

They should think of strong, associative images that may access the feeling of the word so that it becomes more encompassing and may allude to other con-nections. For example: death equals dead bird, or a museum bird with a tag. This image suggests death but also conjures up environmental and sociological asso-ciations. With this information, students need to retrieve images that support their fears and start to engage these images, proceeding from a representational state to a more metaphoric state through the process of abstraction.

The drawing starts by manipulating representational images. These shapes will become evocative by the suggestive power of their form, placement, and color associations. Shape becomes metaphor. Eventually, individual composi-tions will be arranged as a large collaborative piece that will require group par-ticipation.

Some words that may provoke student thinking on this subject are:

snakes	racism	sex	AIDS
rats	roaches	violence	spiders
death	fire	damnation	war
germs	cancer	anthrax	guns

Class project.

Detail.

Words as Triggers

ANNE E. HOWESON | *Royal College of Art, London, England*

The creative visualization of words.

Start by making fifty to a hundred small drawings on separate pieces of paper, using one of the words below as a trigger for each drawing. You may work from life, photographs, or your imagination, or some combination of these. The drawings may comment upon or express ideas, or they may objectively document and/or describe the word. The idea is to build a bank of images as a starting point for the next part.

palimpsest	brother	bridge	carrion
seated woman	letter	tunnel	feral
untitled	psychological	melancholy	curtains
concentrate	pen	couch	spiral
vertigo	body	room	stage
door	foot	cupboard	table
dog	island	danger of death	underground (subway)
mother	tower block	self-portrait	cool
house	doctor	trembling person	skeleton
learning to swim	sleeper	mum (mom)	baby
restless horse	cat	dad	comb
safety pin	road	window	joke
ladder	face	basket	bungalow
pen	family	lovers	bullfight
canal	opponent	fault	grief
passage	fly	wrestling	marriage
running	music	fool	hat
crying	speech	memory	architectural
warhorse	temple	bad man	laugh
cockpit	corpse	transparent	spirit
pantomime	inferno	monument	skyline

Create ten to fifteen larger images based on the previous small drawing set. Add new elements to make more complex compositions, or draw your original ideas differently or in greater depth. Title the drawings (this could be incorporated into the drawings) by either using a single word from the list or by adding a word or two to make a sentence. Your drawings could all revolve around the same themes[4] or connect in a looser way. Somehow they need to be seen as a series.

I remember I had nothing to go back to so I sat on a bench in the shopping centre, the **temple** which people come to worship in about once a week.

Kate Cunningham. This Way Round.

Bernadette Bacino. War/Turmoil.

Alphabetic Landscape

Janet Maher | *Loyola College, Baltimore, Md.*

Letters composed with different perspectives in the same space.

Most of the word-based assignments in this book are concerned with the words' meanings. Janet Maher's problem is literally about the letters of the word.

> Pick a short but potentially profound word consisting of three to five letters. You may also use your initials. Draw a wide horizontal rectangle, with dimensions such as 6" × 12", on an 18" × 24" sheet of paper. Place the letters (using the capital form) in this field. Compose them using different perspectives within the same space, illogical though this may be. The letters should break up the space in a dynamic way; they may overlap, change size (become smaller in perceived distance), break though the field edge, or be cut off by the margin.
>
> Complete the negative areas so that they provide an environment for the letters that either makes sense with the meaning of the word or twists it to become ironic. Use the rules of atmospheric perspective to create the sense of deep space within the shallow border. The use of color is an option that may change the impact subtly or in a bold way.

Success with this exercise is dependent on having acquired certain skills, including one- and two-point perspective. It is also a good idea to practice letters that are straight (*T, H*), angled (*V, N*), and curved (*C, B*), prior to embarking on the final piece. Chris Van Allsburg's children's book *The Z Was Zapped* is a good reference.[5]

Text Collaboration

Greg Porcaro | *University of Wisconsin–Whitewater*

Inspiration from remembered snippets of words.

Greg Porcaro's assignment comes out of his wish that "life came with a soundtrack like in the movies," enhancing events both significant and trivial. Many song lyrics and snippets of text resonate with such power and intensity that they have been ingrained in his mind.

Students are asked to think about their life's events and recall memories they associate with a specific form of written word, such as a song lyric, poem, or story. The text, which may range from one word to multiple sentences, must carry a strong emotional/personal association. This connection is usually the reason we have remembered the lines. Memory may inspire the text or vice versa.[6]

Students then choose the one memory and written passage that generate the strongest imagery, and are encouraged to visually recall the incident through stream-of-consciousness writing. The imagery they choose to develop must relate back to the text-inspired memory on some level, maybe by depicting the physical space or a psychological interpretation of the event. Students are asked to research all the visual references needed to create the imagery.

The text must be included in the drawing but remain secondary to the image. The piece should reverberate with the strong aesthetic impact of visual imagery layered with language.

Richard Pierick Smith. Sleep Aid.

The List Assignment

DUANE SLICK | *Rhode Island School of Design, Providence, R.I.*

Taking off from imaginative sequences of words.

There are many variants on the idea of making drawings that take off from certain verbal sequences. Duane Slick has set up a kind of menu of choices to spur his students to partake of more imaginative visual nourishment.

> Students select a word or sentence fragment from column A and combine it with one from column B. They may elaborate on the combination however they choose, but a selection from each column must be the starting point for the assignment. When two or more students select the same phrase, the project gains interest. How three people interpret "the son of outer space" or "the daughter of the insect world" can be enlightening if not dramatic.

A	B
I dreamt of	pollination
I am	the stomach
The son of	outer space
The future of	gone fishin'
I love	atomic particles
The ecstasy of	gender
The opposite of	endings
Fear of	ammunition
The archeology of	poverty
The anthropology of	honor
The ghost of	the dream
The public	the dictionary
The politics of	the private
I consume	the secular
The mechanism of	ice

The absence of	parallels
The project of	vulnerability
The circus of	X-ray
(A) tradition(s) (of)	hierarchies
The breath of	order
The mythology of	drought
The daughter of	yellow
I hate	luminosity
Inventory of	the sun
The nature of	long shadows
In the shadows of	nature
The deceit of	the insect world
The price of	epiphanies

The assignment: a set of images/series of drawings that use any or all of techniques you know.[7]

Craig Hill. Inventory of "Jet-Man's" Ammunition.

14 | Digital / New Tech Assignments

\mathcal{F}AX MACHINES, COPIERS, and computers have become commonplace, and artists have noticed that what these machines do with, to, and for images is interesting and sometimes creative. For students the ability to use these tools as part of their drawing experience is liberating. Because the machines permit endless manipulation without losing or damaging the original, students can take chances that would otherwise seem too risky and thus push their work to new levels. They can also create cinematic movement, which is the real turn-on for some people in a class.

Renee Meyer.

Zine Project

CHRISTINE BUCKTON | *Harford Community College, Bel Air, Md.*

The creative possibilities of cut-and-paste, photocopied self-publications.

Here is an assignment that stretches the scope of this book. Christine Buckton says that it deals with issues that do not usually surface in a drawing class, such as creating serial and sequential imagery, themes and consistency, and the relationship between form and content.

"Zine" (pronounced *zeen*) is the slang term for self-published and usually photocopied magazines or books ranging from journals and information documents to comics and artists' books. The project may be any size, with a minimum of four pages, and must be created using a photocopier. Students should make enough copies for each class member plus ten. Within the zine, students have complete freedom. It may contain images only or incorporate text and illustration.

Students must become familiar with the limitations of a zine in terms of size and image clarity. Class discussions focus on technical aspects of photocopying, layout, and binding (staples, hole punches, wire, or ribbon).

Images always degrade when photocopied, and students need to find creative ways to work within the limitations of a black-and-white copier. (In places where a color copier is available, or where students have computer skills, the possibilities increase dramatically.)

Traditional materials look very different when photocopied. How will the drawings translate, and how will color be added? Class discussions involve such issues as how different materials will appear (charcoal, ballpoint pen, cut paper) and the use of stamping and stenciling techniques. In addition, the same drawing elements, or collage fragments, may appear repeatedly on several or all pages.

"There is a sense of validation that comes with self-publishing," says Buckton. "Creating a published work, even in small numbers, gives a seriousness, reality, and energy to the project."

Object and Document

AARON FRY | *Massachusetts College of Art, Boston, Mass.*

Transforming drawings into moving sequences.

Aaron Fry's assignment is among several in the book that encourage students to find out as much as possible about an ordinary item—but only he has them then turn their drawings into a film.

First compile visual data from three single everyday objects of your choice, using a variety of drawing techniques, materials, and representational systems. These drawings become raw material for a sequential exploration of your object.[1]

Have students bring three objects for consideration. Discuss and then narrow your choice down to a single appropriate object that will sustain you for forty-five drawings. On $8\frac{1}{2}" \times 11"$ paper, make five drawings for each of the following nine criteria: (1) points/dots, (2) line, (3) shape, (4) value, (5) texture, (6) color, (7) point of view, (8) movement, and (9) abstraction. Vary the pace and duration of each of your drawings from 1 minute to 5–10 minutes, and then select the twenty most successful ones. Criteria for your selection will sometimes shift from drawings that work well as single images to drawings that act as transitional frames or drawings that will create compositional rhythms in your sequence.

For the next steps you will need a scanner, Adobe Premiere or Apple iMovie, and a Zip disk. Scan the selected drawings into the computer, cropping them in ways that allow you to make compositional relationships between drawings. Sequence them into a small 40-second movie in Premiere, using transitions and repetitions, and considering duration and overall sequential structure.

Alik Arzoumanian. Starfruit.

David Baniszerski. Schematic.

Fax Project

DAWN GAVIN | *University of Maryland, College Park, Md.*

Make a drawing guided by the idea that it will be faxed.

Not surprisingly, several assignments involve various forms of current technology. Dawn Gavin asks her students to make a drawing guided by the idea that it will be faxed.

This notion inherently raises interesting questions regarding the nature of a facsimile (think about copies, duplicates, multiples, replication, cloning, etc.). The technology involved in the very process of transmitting a fax should be a fundamental consideration as you develop your ideas and image. The visual information will be "read" and transcribed into sound that is then transferred down a phone line before it is unpacked back into visual information. Your outcome should therefore address coded language in some way.[2]

While scale is obviously restricted by what can be passed through a fax machine as a single sheet, this should not necessarily limit your options. A larger outcome can be generated through tiling, or a single sheet may be part of a series (permitting time to be an active element in the process).

Once the fax assignment has been collected (having been faxed to the instructor), it is installed in a grid format in the studio space. Students are encouraged to talk about how their ideas developed and the means by which they visually resolved their work. Then each student is asked to select one fax sheet made by another class member.

Now make a photocopy of the image you have selected (returning the "original" to the wall), and use it to form the basis of your second work. Consider ideas about "infection" or "cross-contamination" on both a literal and metaphoric level. Do issues of ownership or property rights affect your thinking at this point? Might these relate to your original subject matter? Fax the new image. Part one is returned to the studio wall and displayed against part two.

Self-Portrait: Invented Texture

Barbara Giorgio | *Ball State University, Muncie, Ind.*

A *portrait emerges from a visible grid system.*

Several assignments are suggested by the work of artists. The idea for Barbara Giorgio's digital problem comes from Chuck Close's portrait images that emerge from a visible grid system.

The project begins with a straightforward digital photograph taken of each student. Students work in Adobe Photoshop and Illustrator to reinterpret the image using planes and value patterns. The digital planar analysis provides students with a reference for a drawing that is made up of invented textures. The result is a visual mosaic created out of textural patterns.[3]

Working with Digital Media

1. Planar analysis of self-portrait. Open the Photoshop portrait in Illustrator. This image will be used as a template beneath the planar study. Using the Pen tool, create line segments connected by anchor points to establish the planes of the face and features. The end result should create a three-dimensional planar analysis of the head.

2. Value interpretation. Using either Adobe Photoshop or Illustrator, introduce different values into the planes. Each plane should be interpreted as a single value. The end result should enhance the three-dimensional quality of the planar study using about an eleven-step value scale.

3. Create a cartoon. Export the image to Photoshop. Enlarge the image to 14" × 17". Depending upon the printer, the image may need to be printed out in four sections. Adobe Photoshop has a grid (View>Show>Grid) that can be used to help divide the portrait into sections and is also helpful for visualizing the grid structure used in the drawing.

Working with Traditional Media

4. Transfer. Transfer the planar image to illustration board and impose a ¼" grid over the portrait.

5. Invented texture. Leaving the grid frank and undisguised, introduce a value scale made up of invented textures as they relate to the values explored on the computer.

Andrea Miller.
Self-Portrait/
Invented Texture.

Animated Exquisite Corpse

Cara Jaye | *Western Washington University, Bellingham, Wash.*

A surrealist game taken to new territory.

The fundamental idea of Cara Jaye's project is not new, but her interpretation takes it to unexplored territory. Her digital project is named after the drawing procedure devised by the Surrealists (Cadavre Exquis), in which a group of artists work on different portions of the same drawing, each person unaware of what the others have put down.

For this project each student will make thirty or more frames that should link up into one long animated sequence. (Computer literacy is not necessary for the student to successfully complete this project, but the instructor or teaching assistant must have digital experience.) The frames will then be digitized, sequenced, and animated.

Students' works will be linked to those of the people whose first and final frames run before and after theirs. The whole animated sequence will then loop into a marvelous never-ending digital drawing.

Students create 30 frames on $8\frac{1}{2}$" × 11" sheets of paper for what they anticipate will be a sequenced animation. (Digital files must have a resolution of 640 × 480 and, at 90 dpi, be turned in on an IBM-formatted Zip disk.)

The frames may be drawings, Xerox copies, collages, digital image files, or the like. Any medium or material is acceptable as long as it will not damage a scanner. The pages may also be shot with the "still-shot mode" on a video camera, using either a tripod or a copy stand.

Students begin by creating the first frame of their 30-frame sequence and then make a copy-machine version of it to give to the person preceding them in the sequence. This allows each student a final frame to work toward. Thus each student's sequence will conceptually or literally merge with the last frame of the preceding person's images when it begins, and will end by blending in with the first image created by the person who comes next.[4]

Usually two weeks are needed between the presentation of the copy of the first frame and the completion of the 30-plus digital frames.

Marissa Archer. Animated Exquisite Corpse.

15 | *Limitations and Handicaps*

*I*T MAY COME AS A surprise that limitations and even handicaps in an assignment can actually open up avenues of discovery. The following drawing problems illustrate some of the creative possibilities released by restrictive instructions. The very idea that limitations may actually spur creativity is important for students to learn, as they generally believe that the most valuable condition required for originality is absolute freedom.

Mary Tasillo. Diagonal Exercise.

Occurrence of the Diagonal

PAT ADAMS | *Bennington College, Bennington, Vt.*

A search for a specific visual direction.

Sometimes important discoveries are made when a limitation is put on a drawing experience. Pat Adams asks her students to look at a landscape, still life, or figure, and record only those instances where a diagonal occurs.

> The directional emphasis on the diagonal alerts body orientation to up, down, and across within the subject matter and renders more vivid its surface dimensions. Sequences of diagonal marks following along the edges of shapes are a form of manneristic interpretation, rather than visual evidence of how the subject is perceived. Note that this assemblage of marks is not contour drawing by other means. These drawings do not proceed from what normal depiction would require but are a search for this specific visual item: the occurrence of the diagonal.
>
> Through the constraints of this exercise, a heightened awareness of one of the specifics within attention, students experience an array of distinctions labeled by Gustav Fechner as "JND"—"just noticeable differences."[1]
>
> The consequence of such a gathering of marks may achieve object depiction; however, the chief benefit to this furthering of seeing is proprioceptive cognizance, which grounds those felt judgments of space, place, position, mass—critical elements in the creation of visual form.

Treasure Hunt

Rosemarie Bernardi | *Keene State College, Keene, N.H.*

Portraits in another time and place.

While it is commonly assumed that the arts thrive on freedom, quite often it is the limitations put on an author, architect, musician, or painter that bring out great creativity. For example, poets often choose forms such as the sonnet or haiku, which have restrictive rules, as a device to provoke inspiration. Rosemarie Bernardi's "treasure hunt" drawings derive from assignments based on a list of requirements that must be met for successful completion. Whereas these prerequisites vary, the final image usually includes a full- or three-quarter-size view of the student.

Before beginning the drawing, students are asked to do research about a particular period of time and make copies of images from that era in their sketchbooks as reference material. Examples that students have used are Egyptian monuments, mining caves, alchemy labs, and speakeasies.

The contents prescribed for the drawing by Bernardi have included, along with another time and place, an interior and an exterior, two objects, five words, and a secret passage. Sometimes she includes media requirements such as ground reversal or collage. She encourages students to be as free in their incorporation of the requirements as they desire: for instance, using X-ray visions of spaces. She also suggests that interiors may not just be beyond a window or door but inside a volcano or within the human body.

When the drawings are exhibited, the requirements are also posted so that viewers can have their own treasure hunt as they search the drawings to discover exactly how each student interpreted the requirements.

Jaechan Lee.

Giselle Levy-Loubriel.
Panorama. *Charcoal.*
11"x 72".

Detail.

Panoramic Drawing

Betsey Garand | *Amherst College, Amherst, Mass.*

Composing in an elongated format.

Habit tends to favor convention, and students (and even professional artists) rarely consciously consider the standard dimensions of the paper they plan to draw on. Betsey Garand's assignment questions the use of conventional rectangular formats and creates an increased awareness of the importance of composition. She shows students examples of the late panoramic scroll scenes drawn from memory by David Park and Chinese scroll landscapes, because her assignment mimics these in its use of an elongated format.

> Students take two sheets of paper, divide each in half, and piece together a drawing sheet composed of four sections that are continuous. For example, a standard 18" × 24" sheet of paper may be divided to create 9" × 24" or 12" × 18" sections.
>
> Starting from direct observation, students draw on each section separately. This facilitates transport of the drawing and makes working on it manageable while keeping in mind the entirety of the composition, spatial references, and working between foreground and background. When the sections are bridged, the drawings are placed beside each other so that connecting elements may be drawn from one piece of paper to the next. The abutting edges must be carefully considered so as to present a seamless image and make sure there are no visual breaks between sections. After all four sections have been drawn, they are joined together permanently with tape on the back to create a drawing that is 9" × 96" or 12" × 72".

This extreme format forces students to deal with perception differently from their normal experience because the field of vision is expanded to include a much wider range. The extreme horizontality of this visual scheme broadens and illuminates ideas of composition and unlimited extension.

Dessiner au Pied

JEFFREY LEWIS | *Auburn University, Auburn, Ala.*

Only the feet, toes, and heel are used to create marks on the page.

Some instructors find it helpful to have students briefly abandon their accustomed drawing habits in favor of a less controllable situation, because it opens up new avenues of expression that might never be discovered otherwise. According to Jeffrey Lewis, Michelangelo once said that artists draw with their heads, not with their hands.[2] This exercise extends the master's analogy to include drawing with the feet as well. It is an assignment where only the feet, toes, and heel are used to create marks on the page.

> With the paper securely taped to the floor on all four sides, students sit before the paper, put a stick of charcoal between their toes, and begin to draw. Their hands may be used only occasionally to manipulate the eraser, either as a drawing tool or as a corrective device.
>
> By wielding the charcoal with their toes, students may be amazed by the variety of expressive line, the wide range of tone, and the compositional possibilities that present themselves through such an improvisational approach to drawing. For some it may serve as the initial moment to relinquish control, restraint, and exactitude and to discover much more about drawing's rich, expressive mark-making vocabulary.

Ty Stinson. Figure Drawing.

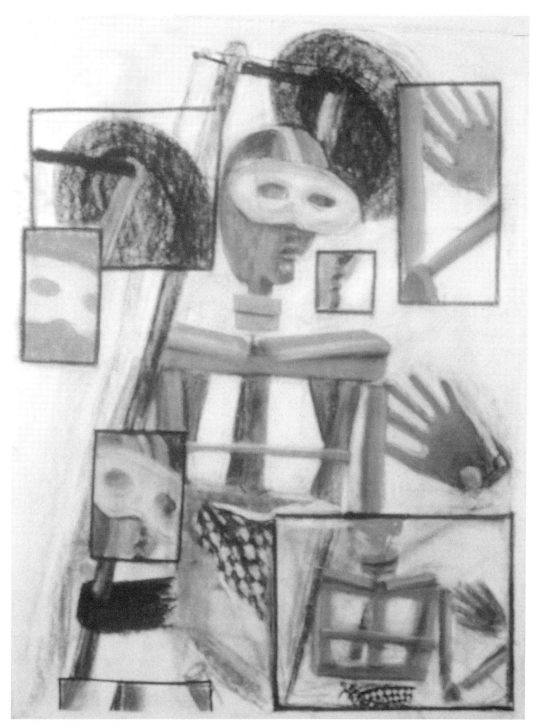

Inge Dóra Gudmundsdottir.

Imposed Box Drawing

Yvonne Petkus | *Western Kentucky University, Bowling Green, Ky.*

Embedded rectangular or square shapes lead to unexpected outcomes.

Unexpected and creative outcomes are explored by imposing varied shapes into a drawing. Yvonne Petkus investigates these possibilities with her students.

Students begin a still life drawing on a sheet of heavy rag paper, using an erasable medium. With the drawing underway though not yet resolved, they begin to draw various rectangular or square boxes directly over parts of the drawing. They should then erase what had been drawn in each box and look to the still life again for other options and solutions to apply to the newly formed open areas.

The size of the boxes, whether they are complete or lead off the page, as well as their rhythm and placement, are decisions that each student will need to determine as their drawings develop. There are also many possibilities in what will end up inside each box. They may choose to enlarge part of the still life (zoom in), which means that they will be pushing the picture plane forward. Conversely, if they repeat most of the original image in a given box (zoom out), they will be puncturing the primary picture plane, forcing the viewer to travel further into the cube of the drawing. Students should also consider how the various boxes can be drawn in different ways to create a dialogue between repeated elements.

A variety of solutions should be encouraged within each piece to increase the complexity and interest of the composition.

16 | A Few More

*H*ERE WE COME to a group of assignments that don't fit into any of the previous categories, nor do they comprise one of their own. They are indeed last, but most certainly not least. Generally speaking, if they are united by any ideas, these are how to treat materials differently and how to reevaluate what is important in a drawing. Maybe what is most significant about them, in the context of this book, is how they illustrate the tremendous breadth of possibilities available for teaching the art of drawing.

Stasia Chung. Origami Bird.

Origami Bird *camouflaged.*

Camouflage or Mimicry Project

Lisa Hart | *Atlanta College of Art, Atlanta, Ga.*

Camouflaging an object through the use of similar values, hues, texture, and pattern.

Lisa Hart opens her camouflage assignment with the following information:

Animals in nature are often camouflaged by the play of light and value. The value of many animals' bodies is often darkest on top where the bright light of the sun strikes. In contrast, the shadowed underbelly of the animal is light in value. When the sun shines on the animal from above, the countershading creates the illusion of the animal's being a similar color value on top and bottom, and allows the animal to be concealed in its environment.

Perception in drawing is dependent on whether each element contrasts or blends with the background and other elements in the drawing. In this project you will be exploring camouflage or mimicry and ways to visually conceal objects. Camouflaging can occur through the use of similar values, hues, and texture, visual or actual. You can also play with camouflaging the form of your object by using pattern to disrupt and dominate the viewer's perception of the image.[1]

First choose the three-dimensional object or drawn image you will camouflage, and then decide what materials and visual effects you need to conceal it most effectively. Solutions that students have presented include:

- Drawing/painting on an actual person and then camouflaging the person among mannequins
- Folded-paper origami birds camouflaged by pattern, texture, or line
- A drawn image of a brightly colored object concealed among similar hues and pattern
- Black and white letter forms hidden in bold pattern

Reconfigured Drawings

Sue Hettmansperger | *University of Iowa, Iowa City, Iowa*

Recycling old drawings into collage breaks your habitual mark-making patterns and suggests an expanded expressive range.

Sue Hettmansperger's assignment is among several that aim at breaking the routine decisions students so often make. She says, "This project is intended to interrupt unexamined habits of drawing and insert new, unexpected visual solutions to image-making. The emphasis lies on the disjunctive aspect of the use of collage as an implicit metaphor for current issues of human identity and cultural reexamination."

Students are asked to recycle their older drawings from earlier in the semester, by cutting and/or tearing them. They assemble a stack of resource materials in the form of pieces of older drawings (of any subject) as well as some collage materials from magazines or found objects. A model is posed in a way that suggests a narrative or psychological content that may be explored in the drawing. Working from observation, these materials are put to use in the construction of a new image in which passages of older works combine with very minimal additional drawing. Space around the model may also be incorporated. The result is arresting in its invention because of the disjunction of recontextualized fragments, and therefore unusual solutions between drawn and collaged areas. By suggesting ways out of the student's habitual mark-making patterns, this activity forces an examination of every move made in the construction and drawing of the image.

"Serving a new function, the reconfigured drawing solutions create a less predictable, visually richer and inventive space," Hettmansperger concludes. "The concept and content of these works can carry a kind of cultural meaning that speaks of the range of experience and dislocation in our contemporary world."

Melinda Kaune. 24" x 18".

Carol M. Klammer.

Calendar

KARL HLUSKA | *Massachusetts College of Art, Boston, Mass.*

ANA MARIA CAMPOS | *University of Massachusetts at Amherst*

A *challenge to think about calendars in unusual ways.*

Karl Hluska and Ana Maria Campos's assignment springs from the idea of a calendar, which, they say, provides a visual means to organize and account for activity and information. The word *calendar* is derived from the Latin *calendarium*, a money-lender's account book. It is routinely thought of as depicting an arrangement of days, months, and years, and a common format takes into consideration the cyclic nature of our earth's rotation around the sun.

For the purposes of this assignment, a much more inventive response is needed. Another definition of a calendar calls it a "systematic and concise arrangement of facts,"[2] and therefore the calendars to be made by the students will reference events, actions, thoughts, and memories. While they must be made of twelve pieces, these do not have to reflect the twelve months.

> To get started, consider the current ways people think about the year as a whole. What different qualities define each month in terms of religious, civic, or personal history; seasonal activities; color; light; and time and its passage? What is the calendar of your typical or atypical day? What other situations might a calendar address? Make a list of all the possibilities you could investigate using ideas, recollections, materials, imagery.
>
> Remember, this assignment challenges you to think about calendars in ways you have not yet considered.[3]

Fifty Drawings

KITTY KINGSTON | *University of Wisconsin–Marshfield*

A *project designed to get you back into drawing creatively.*

Instructors are often concerned about the habits their students unconsciously fall into. Kitty Kingston addresses this issue in her assignment when she asks, "Are you repeating yourself by working with the same medium, employing the same technique, or using the same format? This problem is designed to get you back into drawing creatively by experimenting with a variety of media, techniques, and supports (paper, board, fabric, leather, wood). Using anything you can draw on with a variety of media, produce at least fifty drawings.

Starting immediately, do five drawings every day. Each day you should work with completely different materials from those you used the previous day. Do not do fifty drawings in one or two sessions, because this will yield similar-looking imagery. All the drawings are to be nonobjective. Think about basic principles such as variety, rhythm, balance, depth, value, line, and gesture. If you are feeling stuck, begin by simply illustrating a feeling or emotional state of mind. Try working with found tools such as twigs, balsa sticks, carrot or potato sticks, cardboard, tennis balls, or crushed paper. Dip these in ink, mud, paint, or other mark-making materials from your kitchen. Or roam the aisles of your local supermarket for other unusual materials. Let intuition be your guide. Do not judge, but be relaxed and experimental. Just do it!

After Kingston's students have completed their fifty drawings, five of them that would be most interesting to expand on are selected during a critique. They should furnish new ideas to use in a finished series of three to five large images. Jeffrey Harder, the student who made the piece in the accompanying illustrations, used pink builder's foam (insulation board) and incised lines with various implements such as a pizza cutter. Vegetable oil was used as a resist to retain the pink areas, while the rest of the board was worked with black ink and black acrylic paint.

Jeffrey Harder. Geometry.

Play and the Creative Process

JACKLYN ST. AUBYN | *New Mexico State University, Las Cruces, N.M.*

Incorporating your childhood approach to play.

Many people are fascinated by children's images and also fondly recall drawing as a child. Jacklyn St. Aubyn's assignment incorporates the idea of play in her students' drawing process.

> Begin by determining what characteristics you would assign to the activity of play. This means you will have to examine your concept of play and even perhaps think about when you were a child and what things you did to entertain yourself. Play is, of course, one of the primary means by which a child develops mentally, emotionally, and intellectually. There are probably things you remember doing as a child that gave you pleasure. Some examples might be:
>
> • Doodling with lines and shapes
> • Pretending one thing represents another
> • Juxtaposing unexpected entities
> • Inventing fantasies about the subject matter
> • Making an image that is simply enjoyable to do
> • Repeatedly copying certain images
> • Collecting things
>
> Once you have decided on your approach, you have to determine what direction this will take in drawing terms. This direction should be related visually to what you have done previously. In other words, this drawing should not be a digression from your artistic development but should fit in with other recent work. It should also be formally and technically successful.

Patricia Steeb said the following about her drawing illustrated here: "To begin the drawing I thought back to how it felt to be a child at the beach. Finding a good seashell was like finding a treasure. For many tranquil hours, I sifted happily through piles of broken shells, searching for the most whole or beautiful ones. I became absorbed in this drawing to the same extent that I was absorbed in my examination of seashells as a child."

Patricia Steeb.

 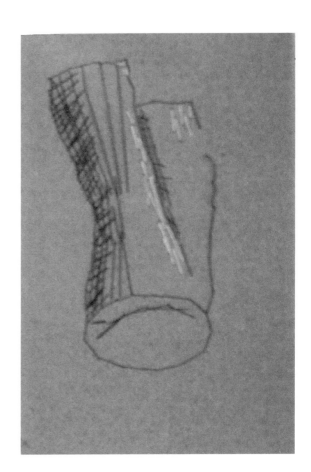

Sharla Lemon. Examples of One Point Project *(chiaroscuro).*
Needle and thread / twigs and ink.

One-Point Project

KATHLEEN STEVENSON | *Weber State University, Ogden, Utah*

Previewing the outcome of an assignment.

Kathleen Stevenson has an unusual approach to whatever her class's current assignment happens to be:

> After I have introduced the current assignment, I ask my students to create a quick response that explores the concept and/or technique. These roughly 30-minute drawings are done on postcard size to $8\frac{1}{2}" \times 11"$ sheets, for which students receive a point.[4] Then the class does a quick (about one-minute) informal critique. Students find this is a fast and easy way to see if they are visually on track and to compare their take on the subject with those of their fellow students.
>
> After explaining the format and technique, I throw in a few "rules," such as allowing only crosshatching, using only white and black inks, drawing with twigs, or rendering only a tiny area of the subject. I find that the more inventive I am with the "rules," the more fun students have pursuing the concept and process. They are less caught up in making things look as expected. Interesting, even funky "rules" increase class energy and participation. This is also an excellent method for exploring nontraditional approaches—for example, creating a self-portrait using needle and thread. As the class advances in conceptual articulation, this project offers an easy entry into some of the more interesting issues of the times.

The one-point project has proved to be an effective and fun class opener and introduction to the topic of the day. (Often if students have missed a class, one of the first things they ask to make up is that day's point project.) The results can be kept in the plastic sleeves of three-ring binders that document the progression of students' level of skill and conceptualization. The project also creates a deeper sense of community with fellow students and makes them more likely to seek each other out for informal critiques and less dependent on the instructor's favorable response. And it can break the procrastination of those students so inclined.

The Paper Blanket

PATRICK TRAER | *University of Saskatchewan, Sask., Canada*

Shifting emphasis from the drawing tools to the paper.

The success of many assignments comes from their ability to view a common problem from a different perspective. Patrick Traer tries to make his students interested in the supports or paper they draw on. His students build a "paper blanket" from pieces of found paper—all of one type or a variety.

Look around at fast-food packaging, old telephone books, grocery product labels, newspapers, flyers, handwritten letters, envelopes. Select materials that have enough tooth to retain the marks you make, do not have too much imagery, and are individually no bigger than a foot square.

Assemble these papers together into one large sheet or "blanket," using whatever you feel works best. Try obvious materials like spray glue, wallpaper paste, staples, or paper tape, even thread and a sewing machine. Look in stores for office supplies, hardware items, fabrics, and notions. Assembling these blankets will take intense labor to make them durable enough to be walked on but also flexible and soft enough to roll up and transport easily. The completed blanket should be 5 square feet or larger (large enough to hide under).

What the assembled blanket looks like should be a determining factor in how you create your drawing. There may be sufficient marks and textures already on the blanket for presentation. If not, consider what distance(s) the drawing will be viewed from. Think about the intimacy of a close-up view and the publicity of distance. As the blanket is body-sized, you might want to explore the relationships between it and your body. Because it can be rolled up and is portable, you could rework the texture by leaving it out in the rain, snow, or intense sun, or cutting it up, perhaps several times, and reassembling it. What you draw is up to you. It could happen before, during, and/or after any of these stages.[5] Your investment in creating the blanket should make it have value for you. Put this value in or find it.

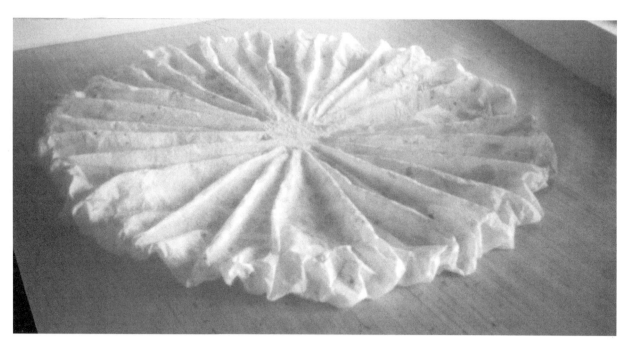

Anne Weidenhammer. Story for a White Page.
Onion paper, cotton thread, B&W photocopy, white ink.

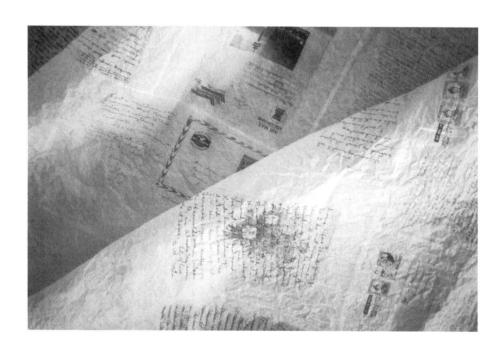

Detail.

Notes

PART 1. ICE BREAKERS

1. Carson specifies ballpoint pen because it is not erasable and students need to take the plunge and be bold in this exercise.
2. Fouquet's students use sheets of 20" × 22" of newsprint paper for the initial drawing. Also, she asks students not to show their hand holding the ball.
3. Fouquet's students use charcoal at this point.

PART 2. SELF-PORTRAITS

1. Erickson prefers that the images not exceed 24 inches square (6" × 4", 8" × 3", or the equivalent in a triangular or circular format).
2. Jackson says, "I have my students use charcoal (or better yet, black pastel) to cover an entire 22" × 30" sheet of rag paper having a medium soft surface, with charcoal (or better yet, black pastel) to create a rich, even, velvety tone of black. They use assorted erasers and fine sandpaper to bring in the lights. It may be helpful to draw grids on the copy and drawing paper to get corresponding lines of demarcation to work from and to ease the transition from 8½" × 11" scale to 22" × 30"."
3. Kruck says, "This assignment is best suited for students who have a good understanding of drawing fundamentals and who have tried self-portraiture and figure drawing. Supplementary reading or discussion materials could include reading about artists such as Cindy Sherman, or Andrea Robbins and Max Becher's photo series: 'Bavarian by Law' and 'German Indians,' *Contact Sheet* 98 (Syracuse, N.Y.: Light Work Visual Studies, 1998)."
4. Morrison says, "Although copies of your drawings from a copy machine are an alternative, they lack the tangible, physical nature of the drawing surfaces. Therefore, original drawings are the preferred material."
5. Varner says, "This assignment works very well as a size and scale problem. My classes enlarge small objects onto 6-foot (minimum) surfaces ranging from traditional paper to bed sheets and fabricated materials."

PART 3. DRAWING FROM THE MODEL

1. Create the body covering from Lycra or cotton knit fabric (about 60 inches wide and 80 inches long) purchased from a fabric store and seamed on a sewing machine. A rubber band or ponytail holder secures the top of the tube.
2. Henry Moore, George Grosz, Sue Coe, and Ben Shahn are examples of artists whose work focuses on social commentary.

3. Helen Golding, whose work is represented here, decided to work in an old people's home residence where her grandmother lived. She observed that the residents had a lot of time on their hands, much of which was spent playing bingo and cards. Her drawing shows her great sense of affection for her grandmother and her friends, and her description is at once amusing and moving.

PART 4. TRADITIONAL ISSUES RECONSIDERED

1. "The floors in our studios are waxed at the beginning of the term, and as they are clean and reflective, I always do this exercise at the beginning of the semester," says Auten. If a shiny black floor is not available in the studio or elsewhere, he suggests using a piece of black plastic instead.
2. A Sharpie brand fine-point marker would do. (The preliminary drawing can be done with light pencil and then drawn over with the felt pen, and the pencil lines erased.)
3. Sonotubes are thick-walled tubes used for casting cylindrical concrete footings and are available in assorted lengths and diameters from contractors' supply houses. Godfrey likes the vertical dimension to equal that of the diameter. Other spatial constructions or problems could be addressed by making the vertical dimension greater or lesser than diameter.
4. As a base for pencil or charcoal, Godfrey uses regular white ceiling or latex wall paint.
5. A commemorative marble monument of ancient Rome, with sculpted scenes around the column.
6. Goodman says, "There should be at least twenty-four colors available to work with. We prefer oil pastels, but chalk pastels, colored pencils, or crayons would also work."
7. Patterson likes to use toned paper for this assignment, as it allows the student to explore the development of tones in two directions: from middle to dark and from middle to light.
8. Stolzer's preference is for soft compressed charcoal in the foreground, Conté crayon in the middle ground, and vine charcoal in the background. This assignment also works well using different tones of ink and ink washes.
9. Another, similarly detailed object could be used.

PART 5. SPACE

1. Aurbach says he shows the class Renaissance paintings with plazas or open spaces where an occasional person, object, or ground pattern such as tiles help to describe or even quantify the areas. "This assignment is a spectacular demonstration of lessons offered by past artists, and it also gives me a way of showing my respect for them."

 Surrealist landscape painters often put this edge (in their case, the horizon line) high up the picture plane.
2. Henry Geldzahler, "A Symposium on Pop Art," *Art Magazine* 37 (April 1963).

3. Materials: large pieces of fabric (including patterned ones), sheets, tablecloths, opaque and sheer materials (like curtains), lots of strong twine, clothespins, and spotlights.

4. As a variant, Erskine says, "Models may be placed in the environment so they interact with it, are wrapped in it, or are partially hidden."

5. As a density guide, Patterson suggests twenty boards for a room of about 15' × 20'. The boards may vary in size and thickness, and any that are not long enough may have a stool placed under them.

6. Because the sticks are propped and not permanent, Patterson advises warning students before they enter the room.

7. Patterson uses about three hours for this assignment.

8. The assignment takes about five hours.

PART 6. LINE

1. This number is a variable dependent on the class size. In a small group, students will have to bring in more objects to create a sufficiently challenging installation. In any class, they may add material if they feel the original setup needs greater variety.

PART 8. REPRESENTATION / ABSTRACTION

1. In Tomlinson's classes each of the three stages takes a week.

PART 9. ANTHROPOMORPHISM

1. Think of Richard Diebenkorn's paintings.

2. Dimick says, "In his book *The Natural Way to Draw*, Kimon Nicolaides describes drawing drapery as an analysis of planar structure. The goal is to make this structure so understandable that a wood carver could create a piece of sculpture based on the drawing."

3. Dimick says, "I show students reproductions of Leonardo's breathtakingly beautiful studies of drapery and discuss the formal systems underlying those grisaille paintings. We then look at many examples of Christo's wrapped objects, from his early wrapped packages and female models, to the much larger wrapped Reichstag and Pont Neuf, to the supersized scale of the pink fabric surrounding the islands in Key Biscayne, Florida. We discuss how his work changes our relationship to the forms he contains or conceals, and how it can heighten our sensitivity to a form's qualities of scale, context, form, etc.

PART 10. ART FROM OTHER ARTS

1. Although there are no outstanding precedents for this exercise, several artists have tackled comparable problems. Marcel Duchamp drew an assembly of geometric shapes and speed

lines, and extended planes of objects to convey the mechanics of motion. Morgan O'Hara draws directly the multiple trajectories of moving things she observes. The futurists, such as Giacomo Balla, overlaid discrete "snapshots" of moving objects. Leonardo da Vinci and Pat Steir codified or simulated the gesture of water. Jasper Johns's drawing *Diver* has "conceptual motion"—arrows and movement lines diagram the possibility of movement (of a swan dive).

2. This was an old film, probably from the 1940s, that Aschheim found in a box of leftovers from a film teacher, Bertrand Augst, so information about availability regretfully cannot be given.

3. In Aschheim's experience, "the films that work best for this exercise are somewhat abstract and have a simple structure, with certain constants and some variation; for example, films of trains, water, the slow movement of boats, or films that have been edited for motion, such as Dziga Vertov, *Man with a Movie Camera*. P. Adams Sitney of Princeton University suggested that one could construct a film loop that would repeat a scene over and over. Furthermore, if the loop were twisted, the scene would reverse from left to right each time it goes through the projector. So, for example, a wave would crash first on the left and then on the right side of the screen."

4. Wasily Kandinsky and Saul Steinberg come to mind. Conversely, some musician's scores, such as those of J. S. Bach, have a great visual beauty. Battle also suggests reading John Gage, *Color and Culture: Practice and Meaning from Antiquity to Abstraction* (Berkeley: University of California, 1999), chap. 13, "The Sound of Color."

5. Battle plays instruments, but for instructors who do not, and feel that this classroom experience is important, she suggests inviting someone from the music department to do a short session for nonmusicians.

6. This project takes something like two weeks.

7. Jennifer Bartlett, *In the Garden* (New York: Harry N. Abrams, 1982).

8. *The Sun's Gonna Shine* and *The Blues Accordin' to Lightnin' Hopkins*, video cassette, 41 min. (El Cerrito, Calif.: Flower Films, ca.1969).

9. Marquez asks for a one-page written statement describing the ideas and the process used to create the drawing.

10. Provide students with all the information about your museum: location, days open, hours, free entry times (or arrangements you have made to give them free entry), and availability of stools or other items that will make their task easier.

11. Italo Calvino, *Invisible Cities*, translated by William Weaver (New York: Harvest Books, 1986).

PART 11. PHOTOGRAPHS

1. Straight likes to show them at 10-minute intervals.

2. Winn says, "To build the camera I suggest using a six-inch-square postal box. One side will

hold a thin sheet of metal with a needle hole hand-drilled through its center. On the side of the box opposite the pinhole, a support should be made to hold the photographic paper. This should be simple enough to load in the dark. It is usually a frame, but taping the paper will work too.

"Exposure times vary depending on the size of the box and available light. My students usually expose, develop, analyze, and begin drawing in the same class period. For more information on this subject, I recommend *The Beginner's Guide to Pinhole Photography* by Jim Shull (Buffalo, N.Y.: Amherst Media, 1999)."

PART 12. UNUSUAL SUBJECTS

1. Obviously there must be a barrier between hunter and hunted.
2. For a class with eighteen students, Lund uses three dresses set up in different locations around the middle of the room.

PART 13. WORD-BASED EXERCISES

1. Other adjectives could be used instead, such as *dramatic, comforting, amazing, forceful*, etc.
2. Artists to consider: Bierstadt, Chia, Polke, Kiefer, Picasso.
3. Some artists, books, and actors to consider in connection with this assignment are Joan Miró, Ellsworth Kelly, Stuart Davis, KOS, Kiki Smith, fairy tales, Eva Hesse, Petah Coyne, Louise Bourgeois, Alfred Hitchcock, Rod Serling (of *The Twilight Zone*), Yves Tanguy, Man Ray, Luis Buñuel.
4. Think of Morandi's bottles and vases.
5. Chris Van Allsburg, *The Z Was Zapped* (New York: Houghton Mifflin, 1987).
6. This exercise may be expanded to include dreams.
7. Slick says, "I include a written component for the expediency of the critique and discussion process. It consists of a minimum two-page paper describing the interpretation of the assignment, plus supporting visual material: photocopied clipping file images or the work of other artists that profiles or parallels the research and scholarship obtained from doing this assignment. The supporting visual material must be organized in booklet fashion. With this material on display, the group can see the multiplicity of thinking patterns and interpretations involved in the project. These prepared notes and concrete references achieve a more productive discussion in less time. This is very useful for instructors with large classes."

PART 14. DIGITAL / NEW TECH ASSIGNMENTS

1. Fry says, "I recommend introducing students to a selection of conceptual and process-oriented approaches to drawing that emphasize drawing as information. For this purpose,

Afterimage: Drawing through Process by Cornelia H. Butler (Los Angeles, Cambridge & London: MOCA/MIT Press, 1999) is excellent. I have also found that *Drawing Now* by Bernice Rose (New York: MOMA, 1976) provides a good range of examples of relevant approaches."

2. The idea of change or transformation from one thing to another is embedded in the very medium that will communicate this information. Consider bar codes, retinal scanning, digital information, sound, biological code (DNA), the Human Genome Project, genetic fingerprinting, virology, Morse code, encryption, cookies, and the internet.

3. Giorgio says, "Students are also required to do research in the library to find examples of invented texture and create sketchbook studies/swatches that illustrate the different techniques used by various artists such as Jean Dubuffet, Vincent Van Gogh, and Pablo Picasso; and patterns found in ethnographic work such as African masks and textiles. After exploring both media and technique, students create a value scale out of a variety of invented textures, using pen and ink."

4. A useful book giving background information for this problem is *William Kentridge* (New York: Harry Abrams, 2001).

PART 15. LIMITATIONS AND HANDICAPS

1. Gustave Fechner, nineteenth-century physicist and originator of psychophysical methods, mentioned in Lloyd Kaufman, *Sight and Mind: An Introduction to Visual Perception* (London & Toronto: Oxford University Press, 1974), p. 71.

2. Quoted in Clint Brown and Cheryl McLean, *Drawing from Life* (Fort Worth, Tex.: Harcourt Brace Jovanovich, 1992), p. 3.

PART 16. A FEW MORE

1. Sources of information about camouflage include:

 Abbot Thayer, "A Painter of Angels Became the Father of Camouflage," *Smithsonian Magazine*, April 1999, pp.116–28.

 Lois Swirnoff, *Dimensional Color* (Boston: Birkhauser, 1989).

 Sandy Skoglund: Reality under Siege: A Retrospective, catalog (New York: Smith College Museum of Art in association with Harry N. Abrams, 1998).

 Wild Survivors: Camouflage and Mimicry, video, *National Geographic*, 1987.

2. *Webster's Unabridged Dictionary* (New York: Simon and Schuster, 1979), p. 256.

3. References to history and contemporary culture help to make this project exciting and successful. See, for example, *Calendar*, a film by Atom Egoyan (ZDF Television, Germany, 1993), production Ego Film Arts, U.S. distribution Zeitgeist Films (www.zeitgeistfilms.com),

1994, and Duncan Steel, *Marking Time: The Epic Quest to Invent the Perfect Calendar* (New York: John Wiley and Sons, 2000).

4. Stevenson reports, "I haven't been giving prizes yet for anything like the most points, but I have started separate critiques for each major project. At these, students vote anonymously for pieces with the most interesting concept, the best presentation/craftsmanship, and so on. I give funky, fun awards of next to no monetary value, but they seem to have real meaning for the students."

5. Traer offers ten additional suggestions if you should get stuck: (1) Choose at least three sites where you can take the blanket and draw from observation. (2) Use the blanket as a diary. (3) Take the blanket everywhere you go and use it in different ways. (4) Sleep on it. (5) Add more paper. (6) Use it as wallpaper and draw on it. (7) Build a second, contrasting blanket. (8) Use a process of removal. (9) Make holes in it. (10) Use it in a performance.